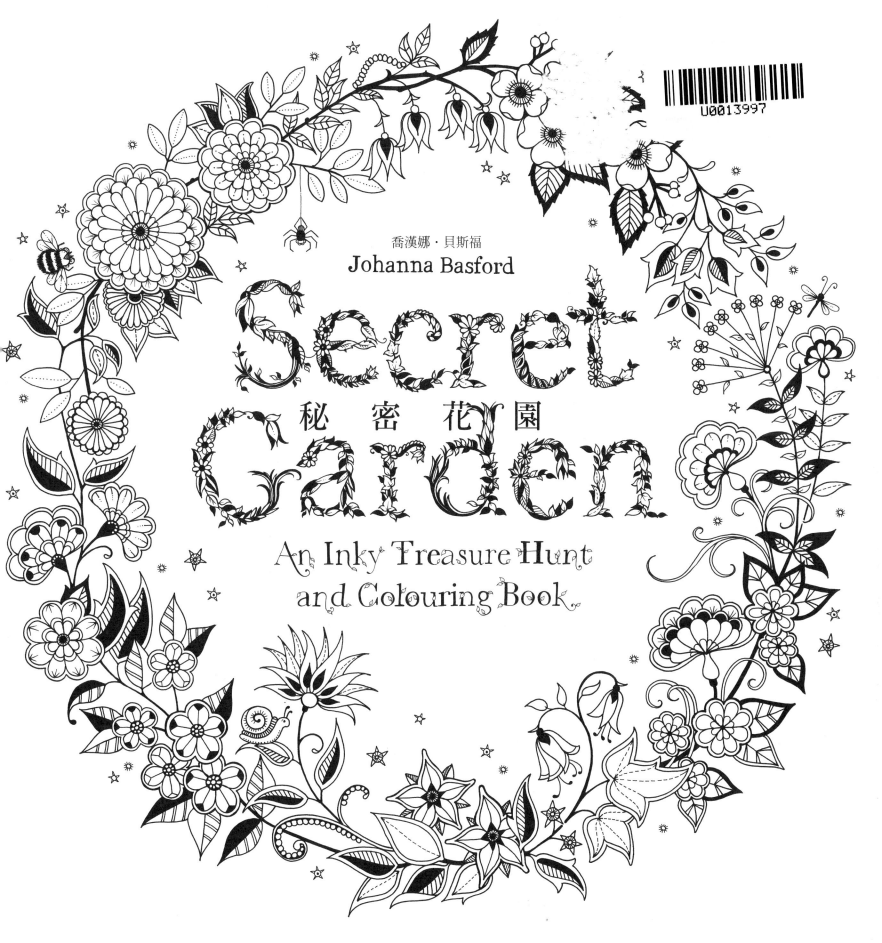

喬漢娜・貝斯福
Johanna Basford

Secret
秘　密　花　園
Garden

An Inky Treasure Hunt
and Colouring Book

秘密花園
Secret Garden: An Inky Treasure Hunt and Colouring Book

作　　者　　喬漢娜·貝斯福（Johanna Basford）
譯　　者　　吳琪仁
總 編 輯　　汪若蘭
責任編輯　　施玫亞
版面構成　　張凱揚
封面設計　　張凱揚
行銷企畫　　高芸珮

發 行 人　　王榮文
出版發行　　遠流出版事業股份有限公司
地　　址　　臺北市中山北路1段11號13樓
客服電話　　02-2571-0297
傳　　眞　　02-2571-0197
郵　　撥　　0189456-1
著作權顧問　蕭雄淋律師

2015年 3 月 1 日　初版一刷
2023年 9 月13日　初版三刷
定價　新台幣280元（如有缺頁或破損，請寄回更換）
有著作權·侵害必究
ISBN 978-957-32-7576-3

遠流博識網　http://www.ylib.com E-mail: ylib@ylib.com

國家圖書館出版品預行編目(CIP)資料

秘密花園 / 喬漢娜.貝斯福(Johanna Basford)著 ; 吳琪仁譯. ― 初版. ― 臺北市 : 遠流，2015.01
　面 ；　公分
譯自：Secret garden : an inky treasure hunt and coloring book
ISBN 978-957-32-7576-3(平裝)

1.繪畫 2.畫冊

947.5　　　　　　　　　　　　　104000063

This book belongs to
這本書屬於

Hidden inside this book there are...

這本書裡頭藏有……

3
chrysalises
蛹

8
spiders
蜘蛛

9
dragonflies
蜻蜓

14
caterpillars
毛毛蟲

20
song birds
鳴鳥

1
treasure
chest
藏寶箱

1
hedgehog
刺蝟

1
cat
貓

16
bees
蜜蜂

1
squirrel
松鼠

5
moths
蛾

1
padlock
鎖

2
hummingbirds
蜂鳥

63
beetles
甲蟲

2
frogs
青蛙

1
shark
鯊魚

4
keys
鑰匙

6
flying
beetles
在飛的甲蟲

16
ladybirds
瓢蟲

5
wasps
黃蜂

13
owls
貓頭鷹

1
message in
a bottle
瓶中信

16
snails
蝸牛

1
peacock
孔雀

116
butterflies
蝴蝶

11
ants
螞蟻

7
slugs
鼻涕蟲

還有一些蝴蝶和甲蟲在書上
是只有出現一隻腳或翅膀！

書末另外附有小圖跟提示，
告訴你每一頁藏的是什麼。

27
fish
魚

3
mice
老鼠

歡迎來到我的秘密花園！

在本書中，你會發現一個魔幻的黑白奇妙世界，
裡面充滿各種奇幻的花兒與特別的植物。

這裡有圖可以上色，有迷宮可以探索，有圖形可以完成，
還有留白的地方可以讓你畫上想畫的圖。
請用細簽字筆來畫上顏色，或者用細筆頭的黑色筆隨意塗鴉。

全書各頁你都會發現，有一些半掩藏的奇特小小生物和在地上爬行的小動物。
另外在花朵裡也可以找找藏身其中的小蜜蜂、蝴蝶跟小鳥。

你可以用書末的小圖清單，
來找出所有你發現的有趣事物到底是什麼。

祝你好運~~

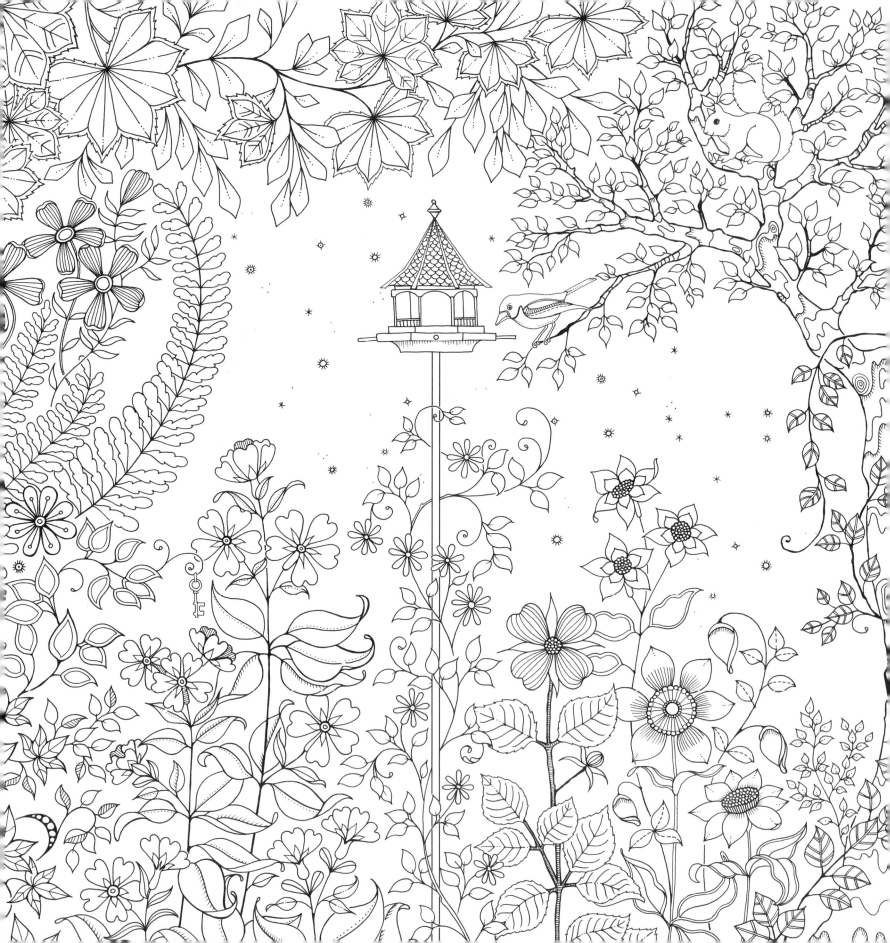

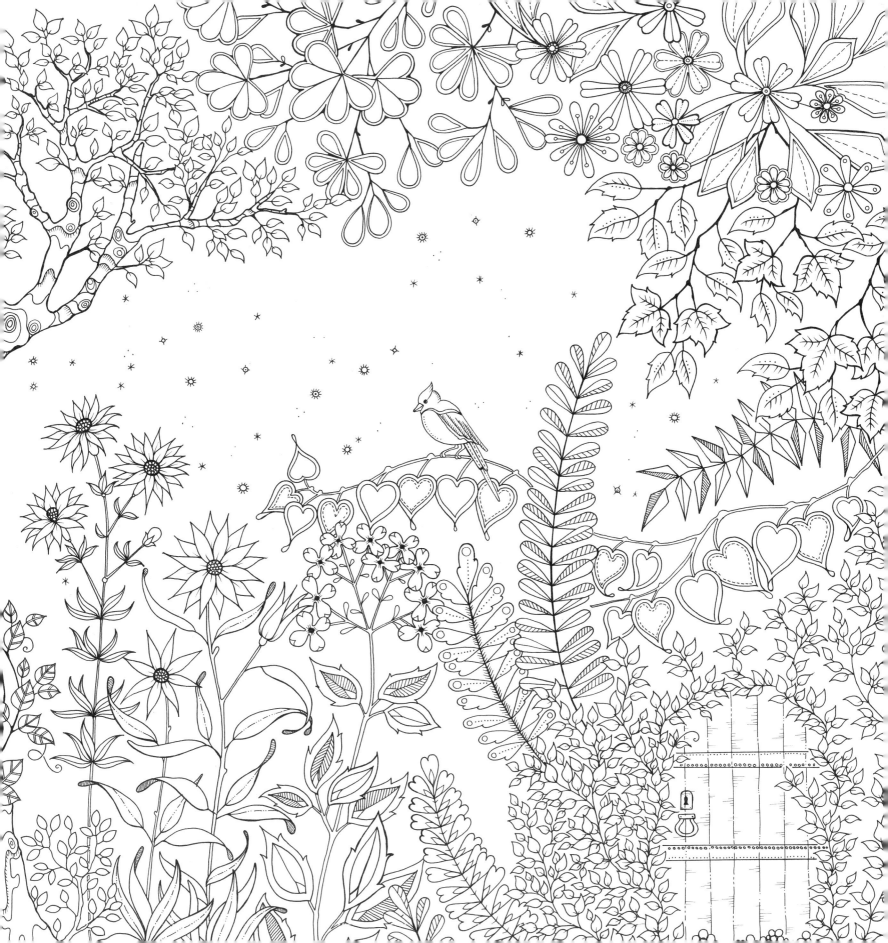

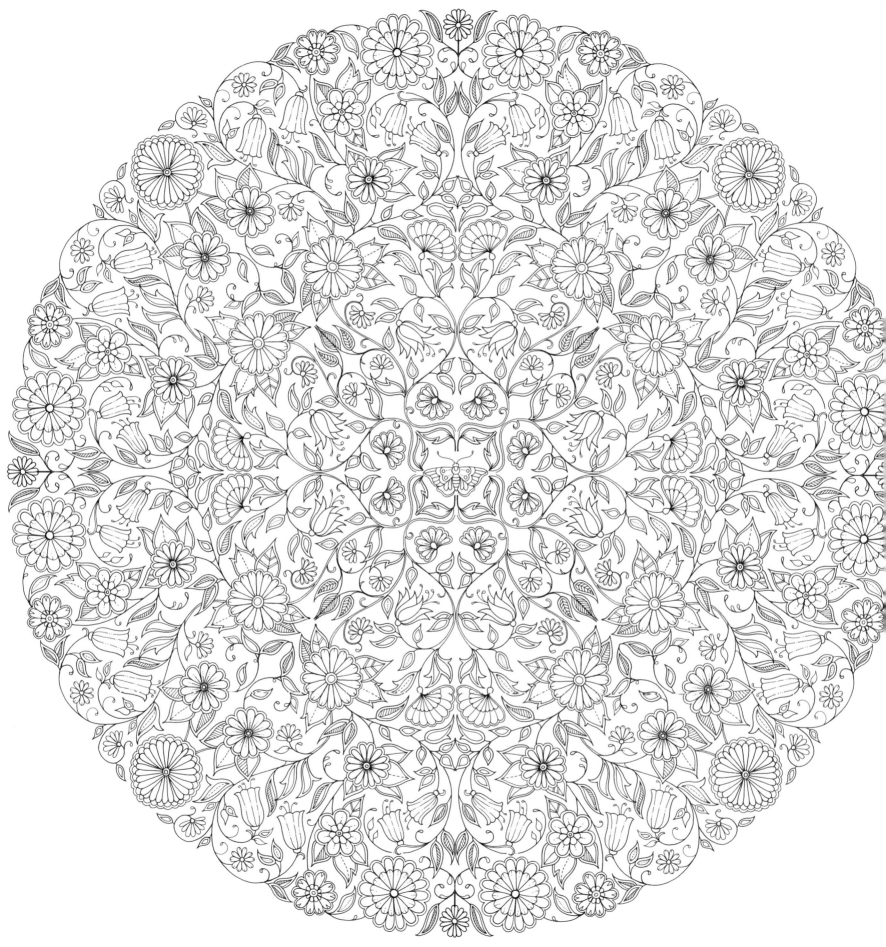

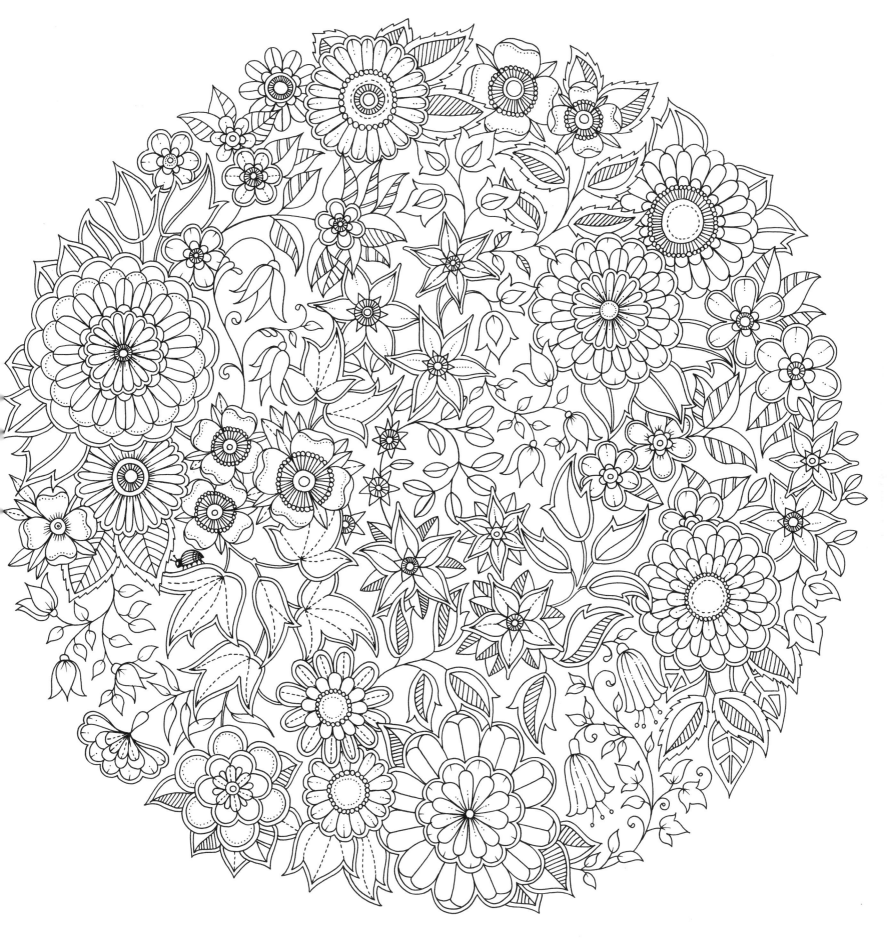

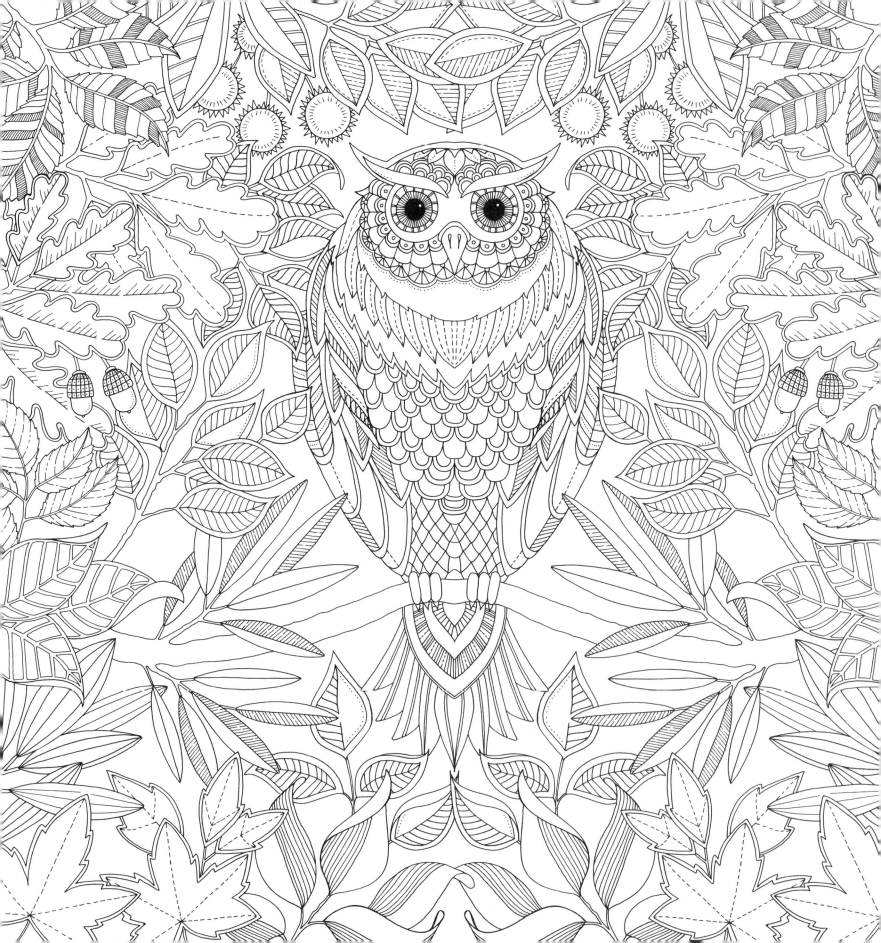

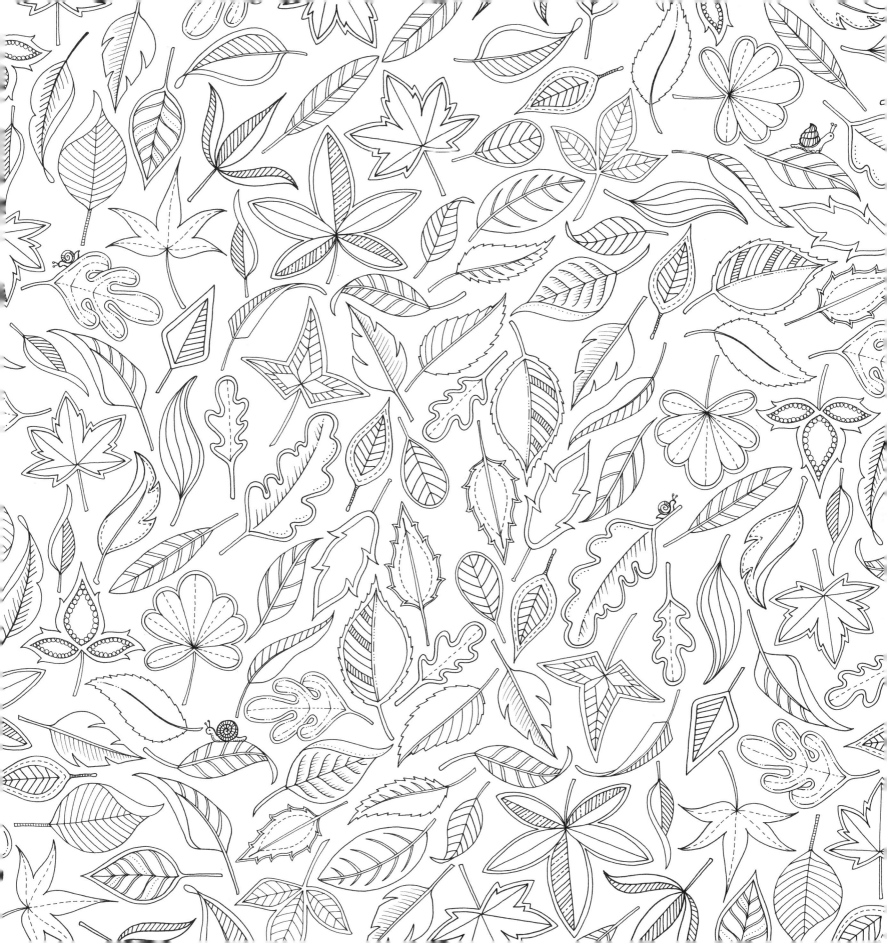

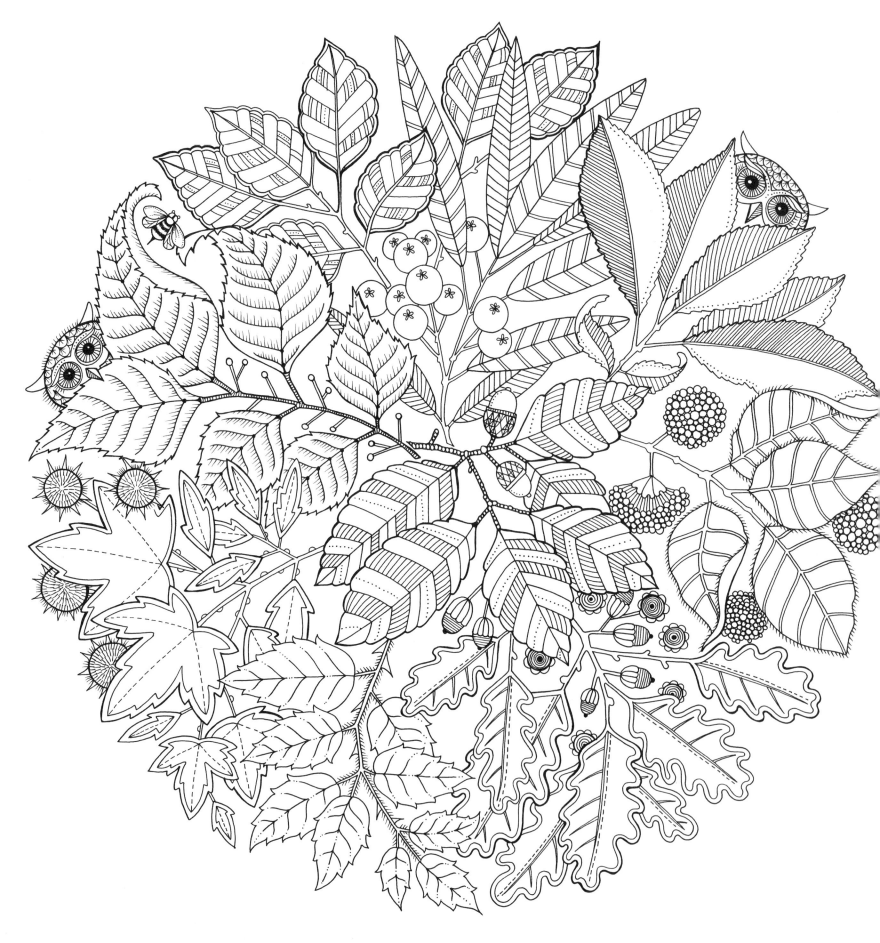

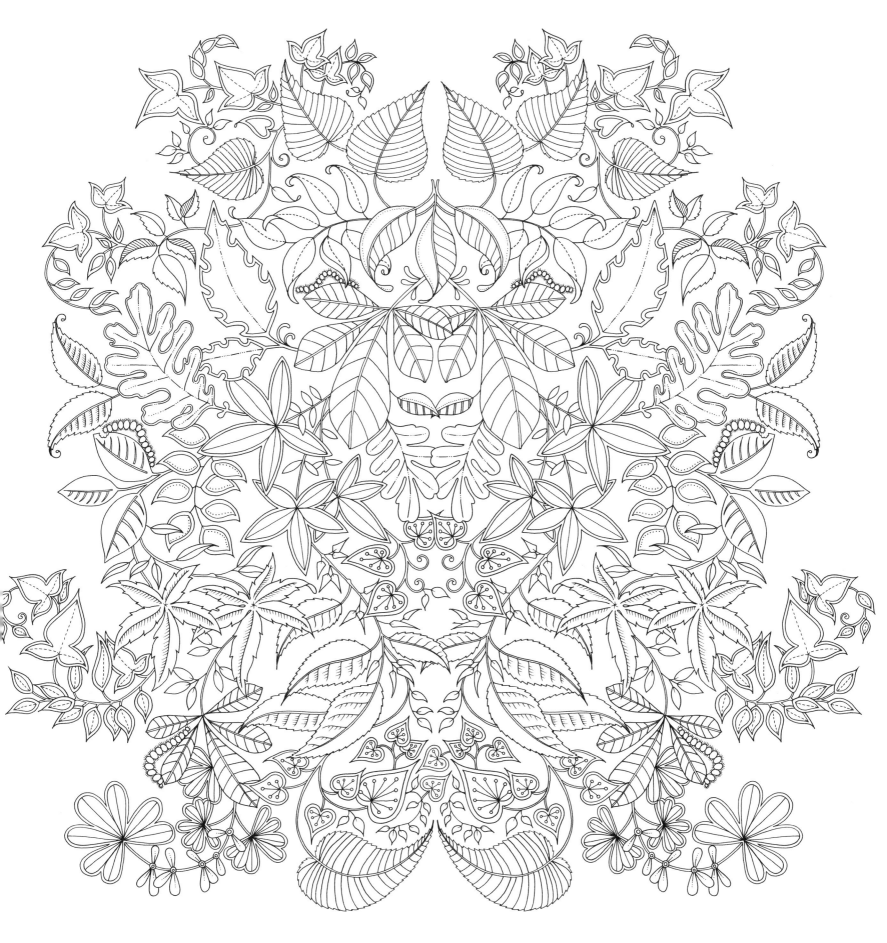

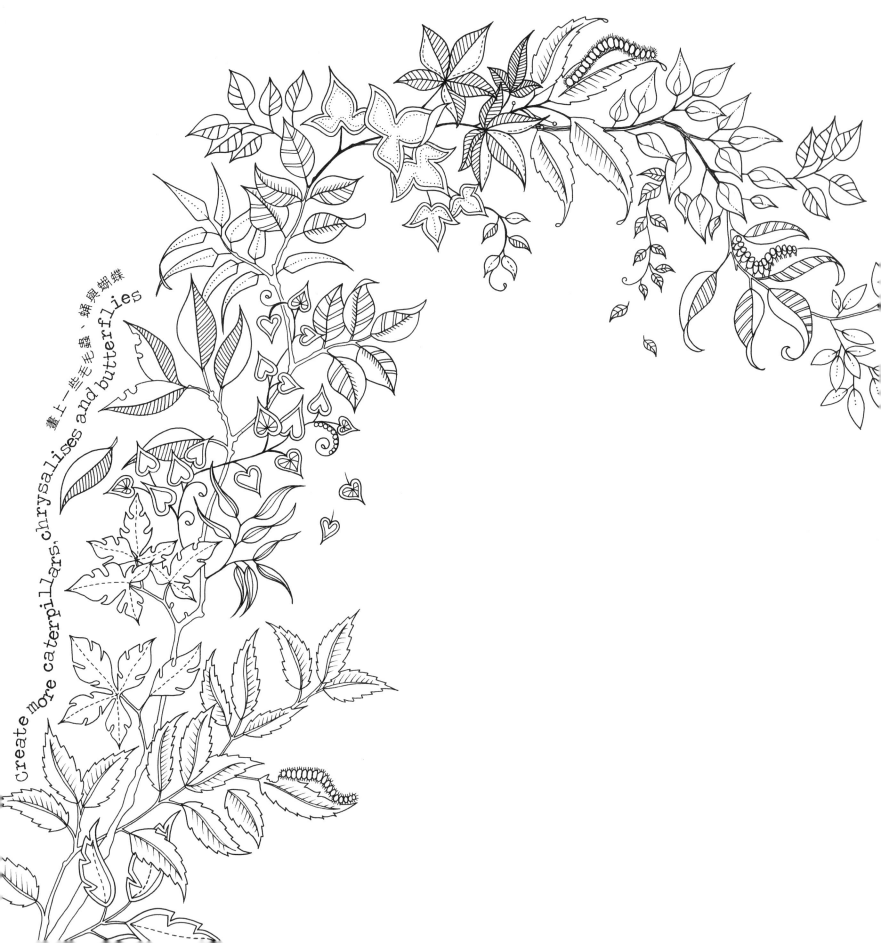

Create more caterpillars, chrysalises and butterflies　畫上一些毛毛蟲、蛹與蝴蝶

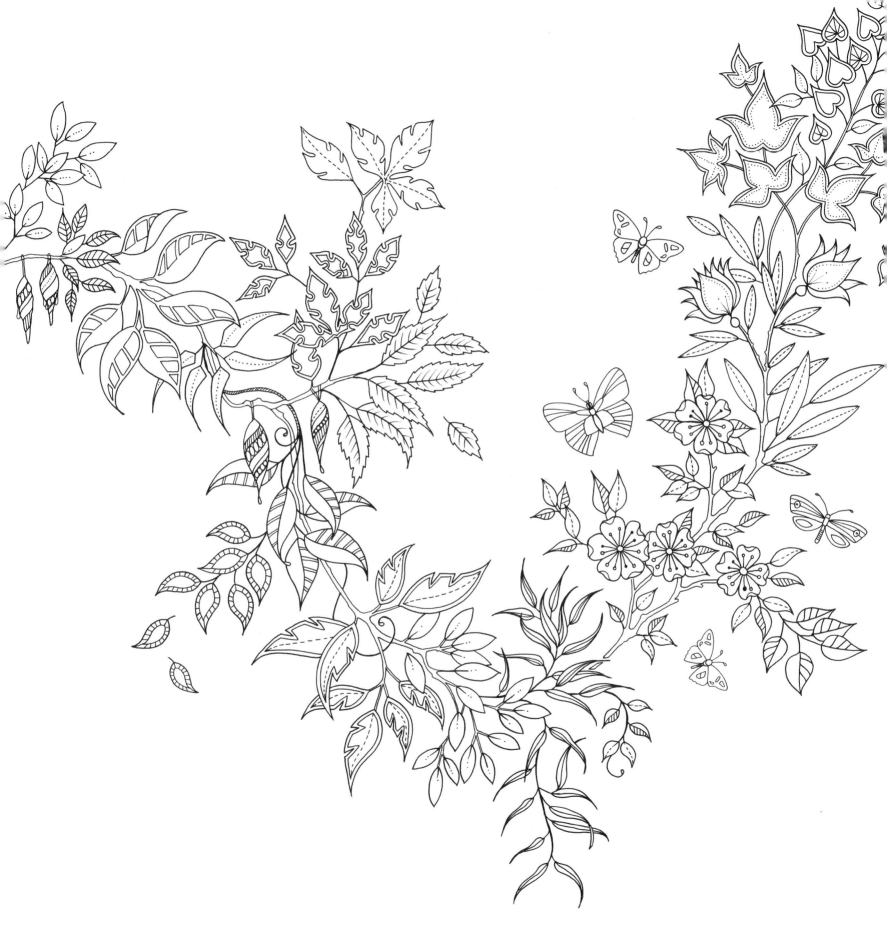

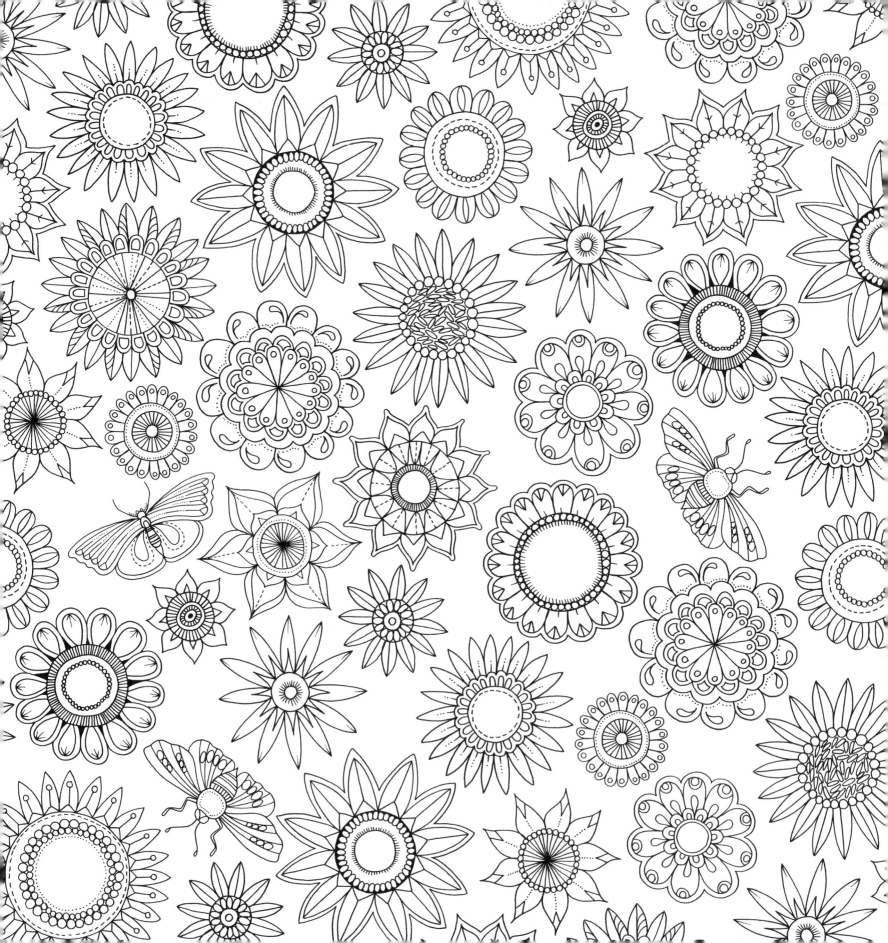

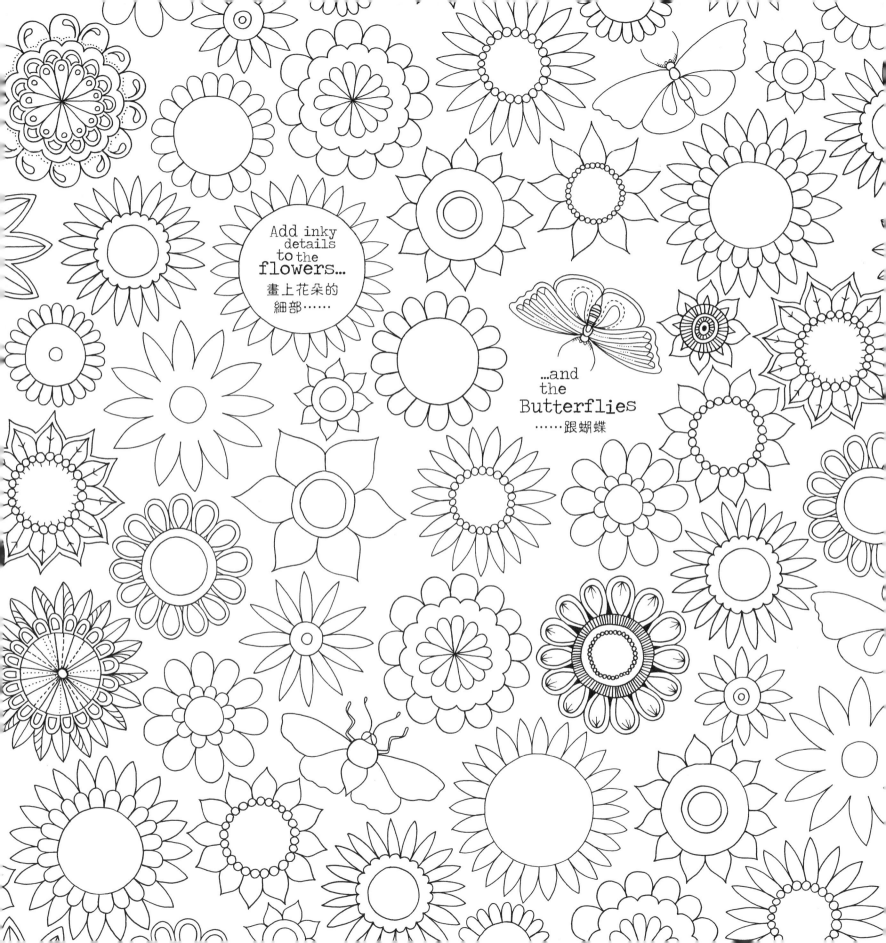

Add inky
details
to the
flowers...
畫上花朵的
細部……

...and
the
Butterflies
……跟蝴蝶

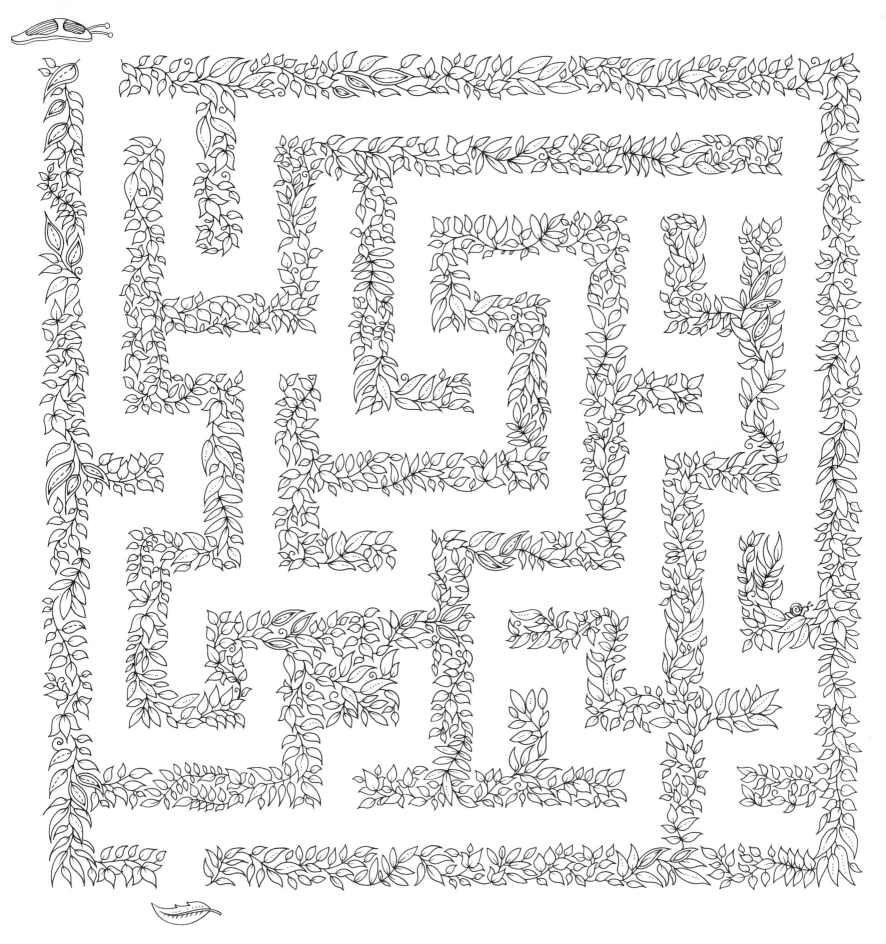

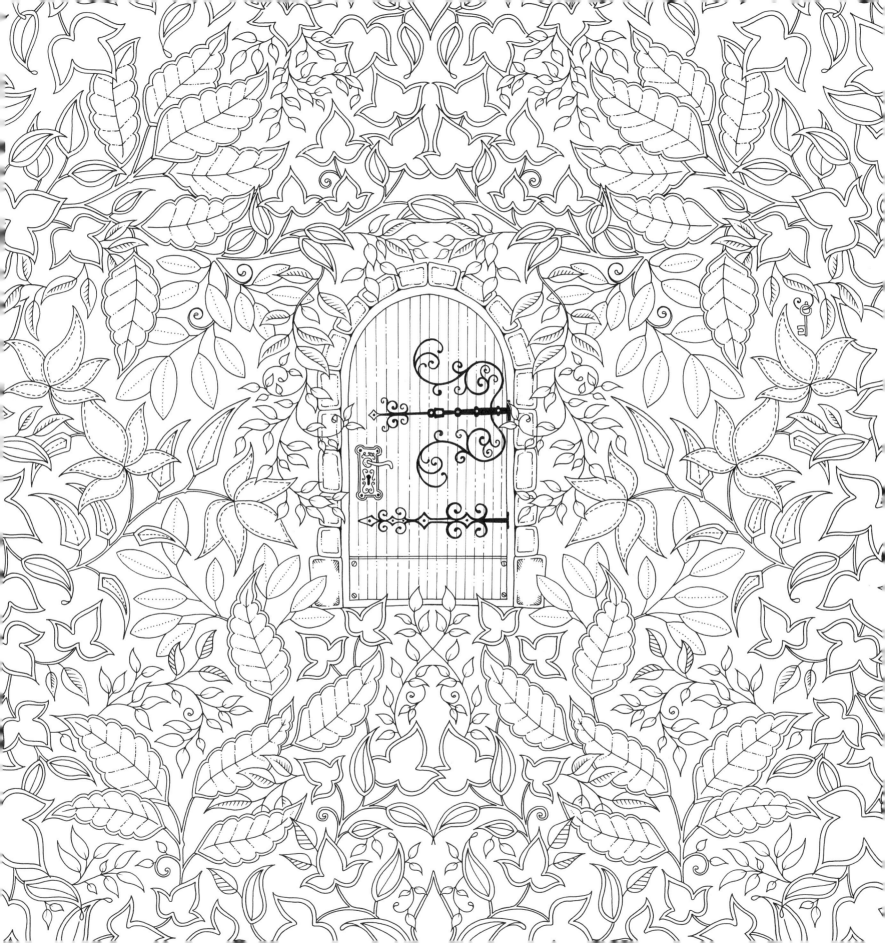

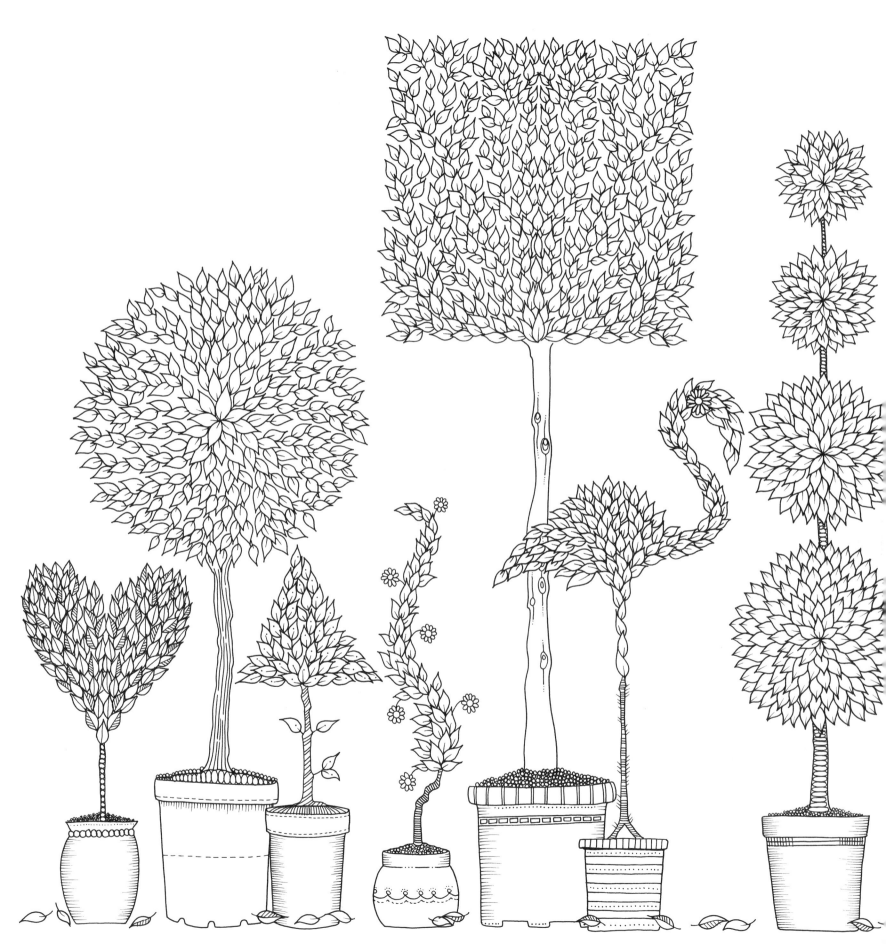

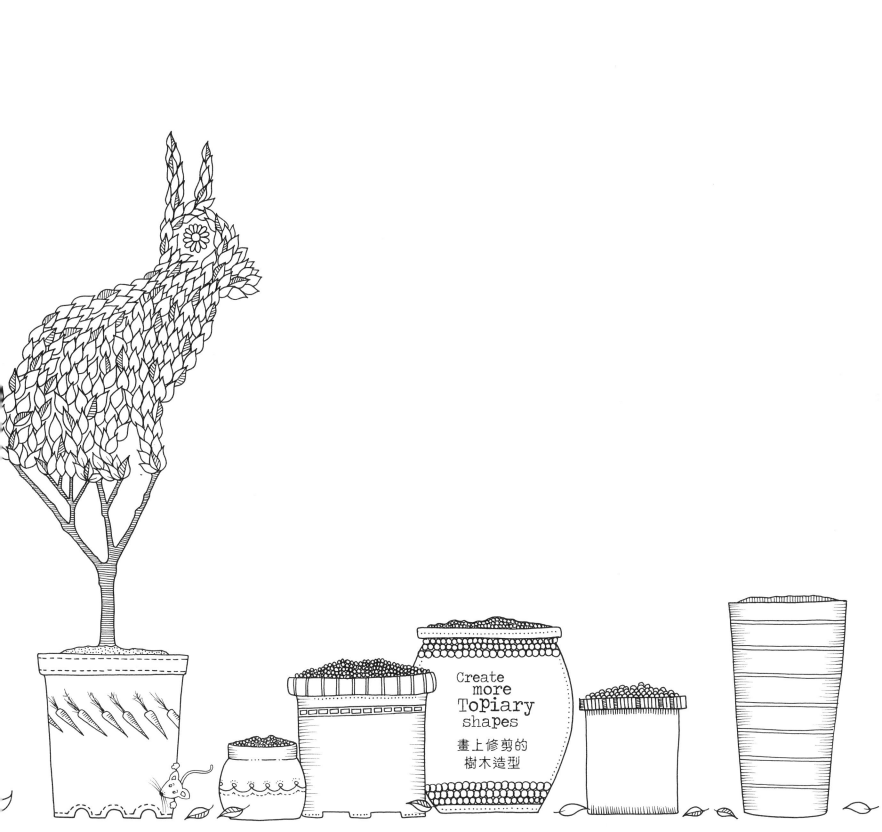

Create
more
Topiary
shapes

畫上修剪的
樹木造型

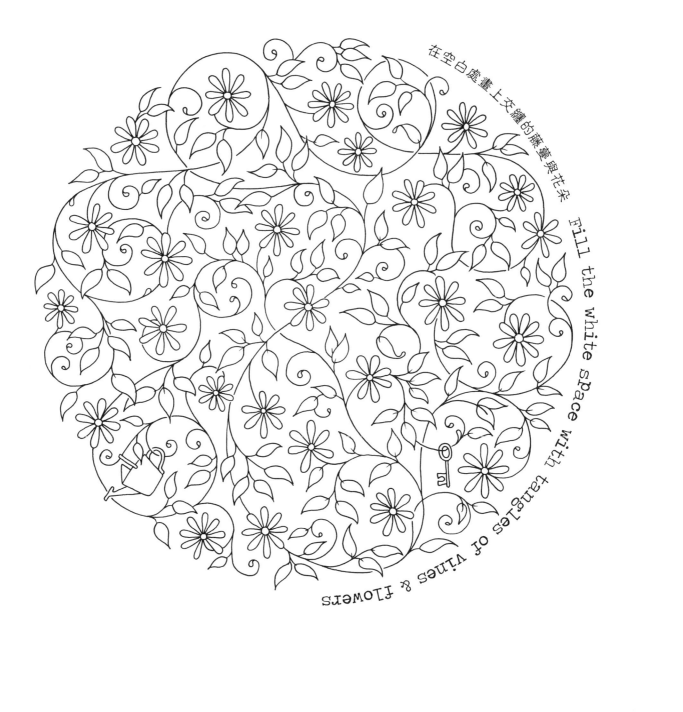

在空白處畫上交纏的藤蔓與花朵

Fill the white space with tangles of vines & flowers

Draw here what the padlock is locking away 在這頁畫上由掛鎖鎖起來的東西

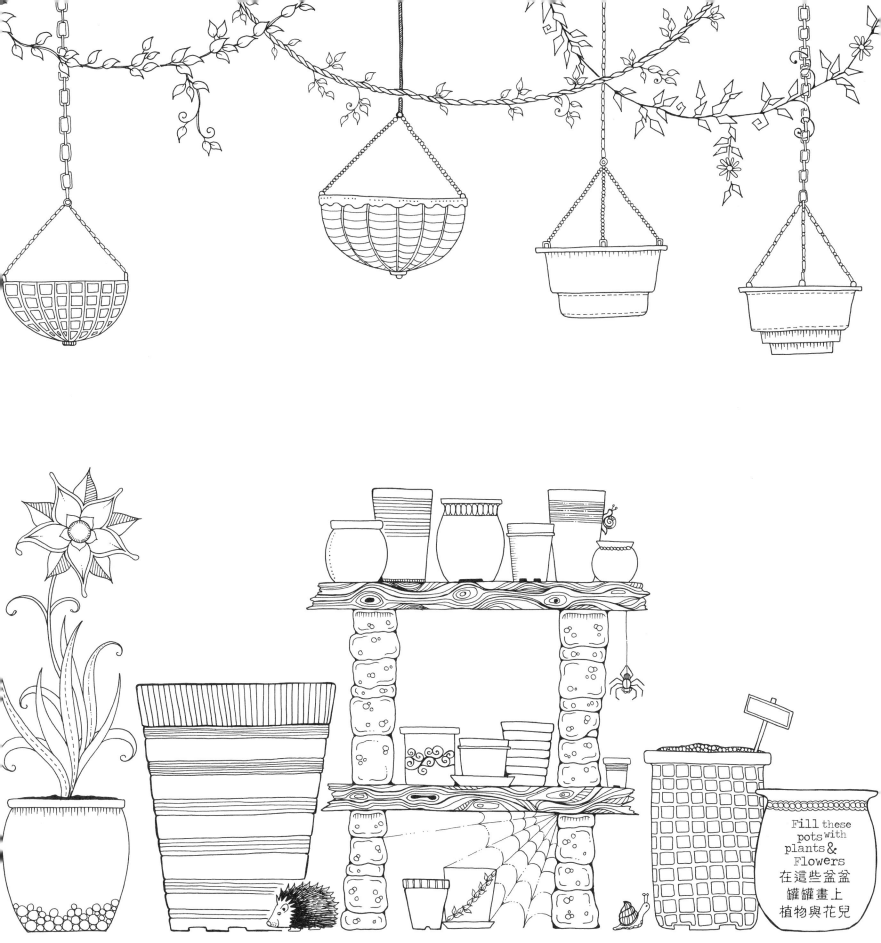

Fill these pots with plants & Flowers

在這些盆盆罐罐畫上植物與花兒

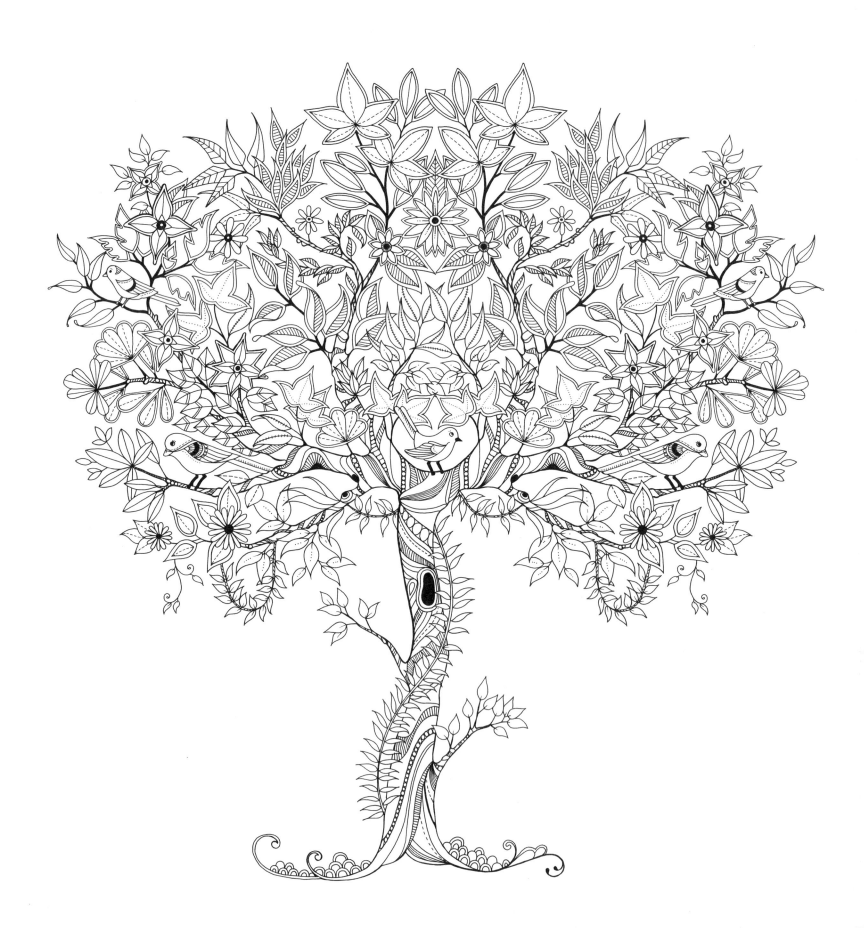

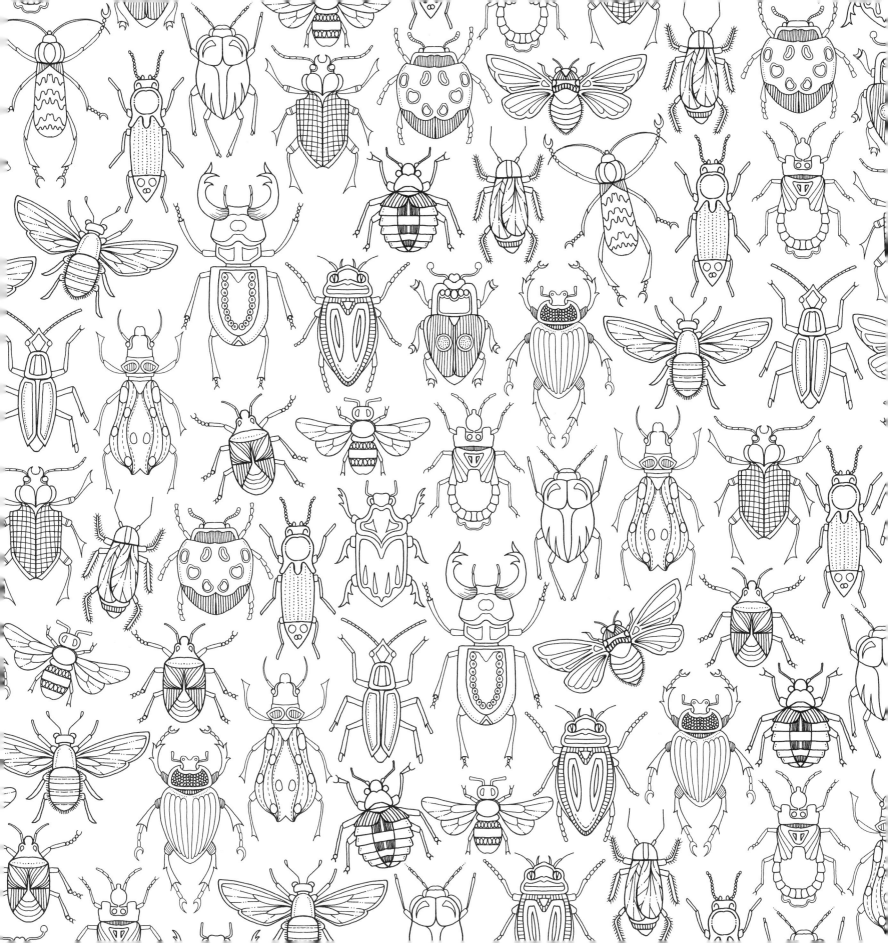

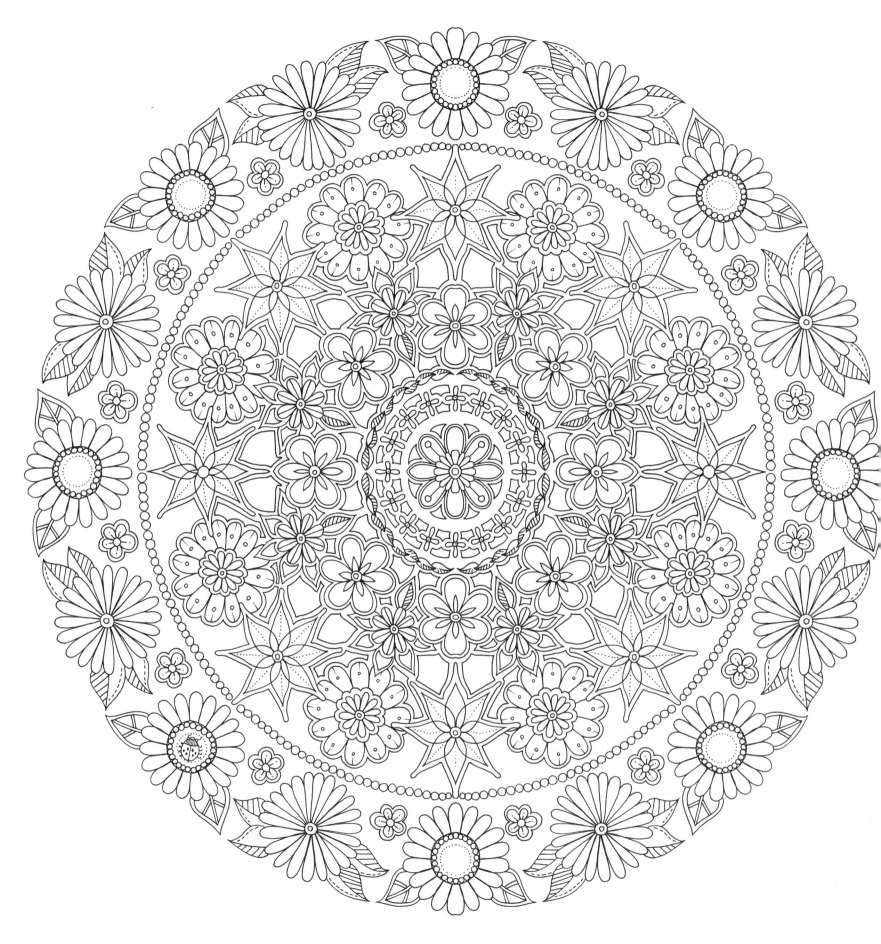

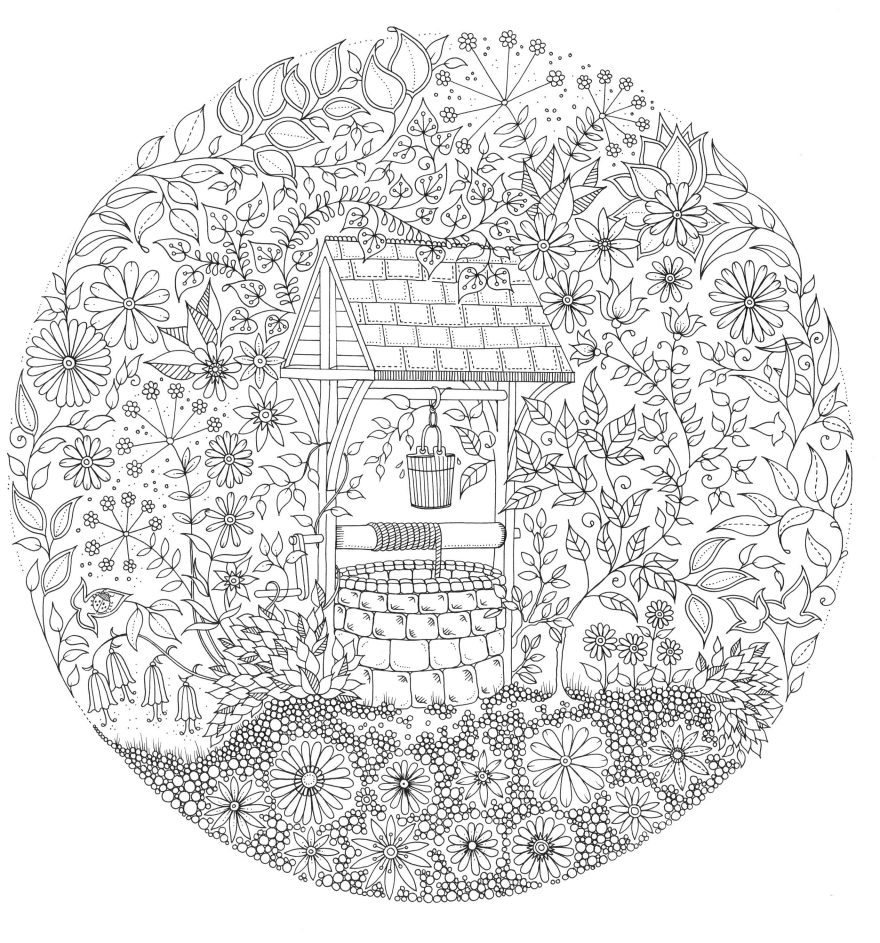

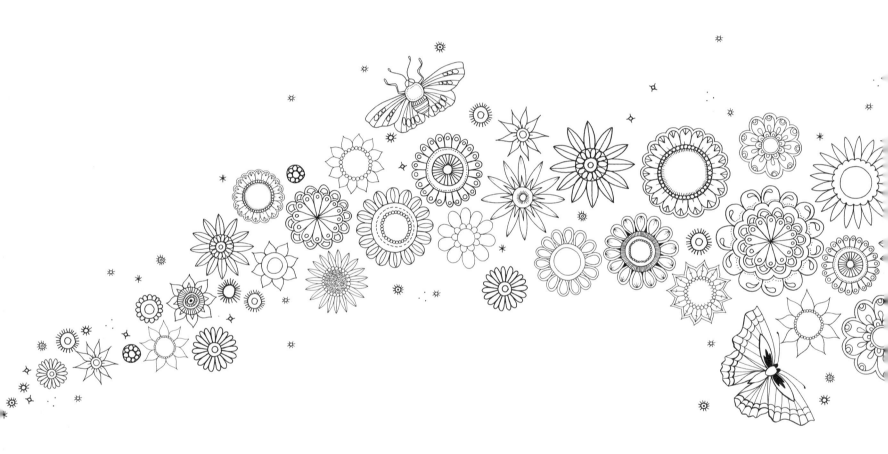

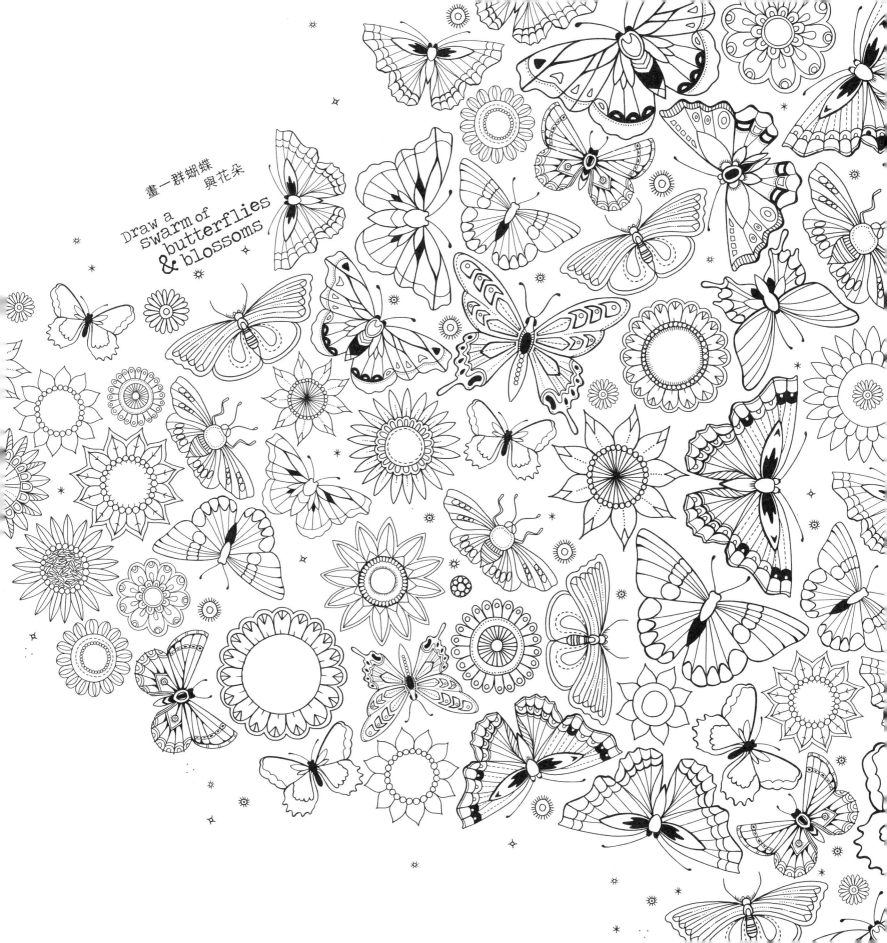

畫一群蝴蝶 與花朵

Draw a
swarm of
butterflies
& blossoms

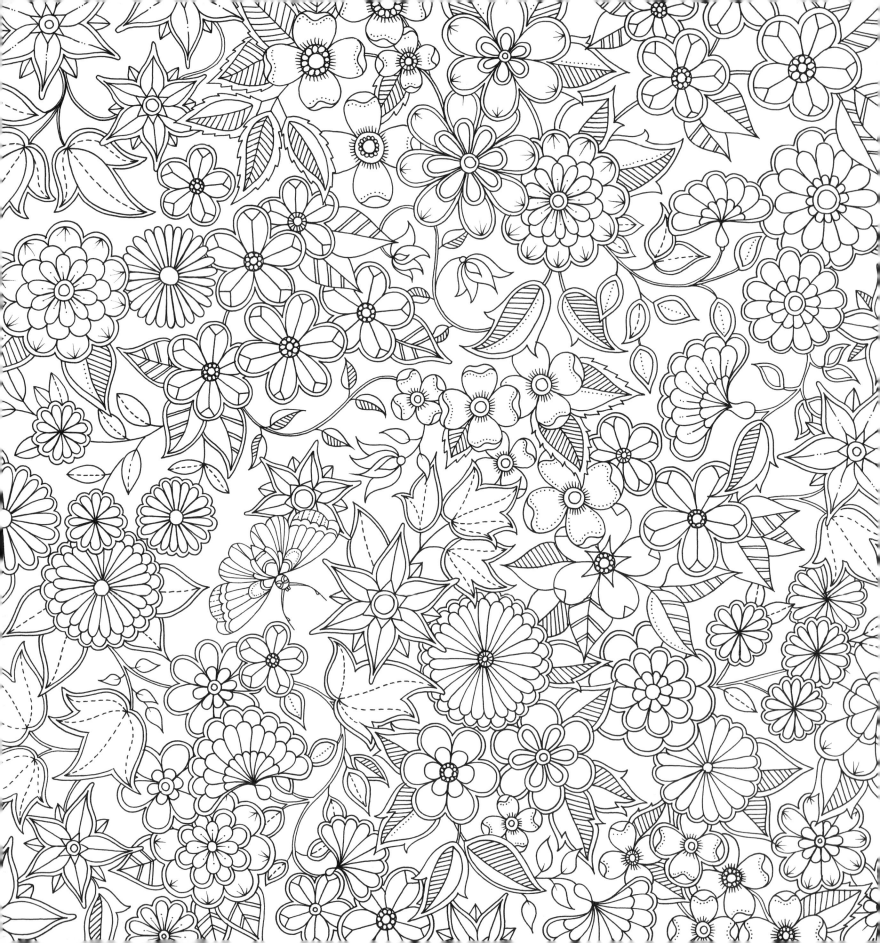

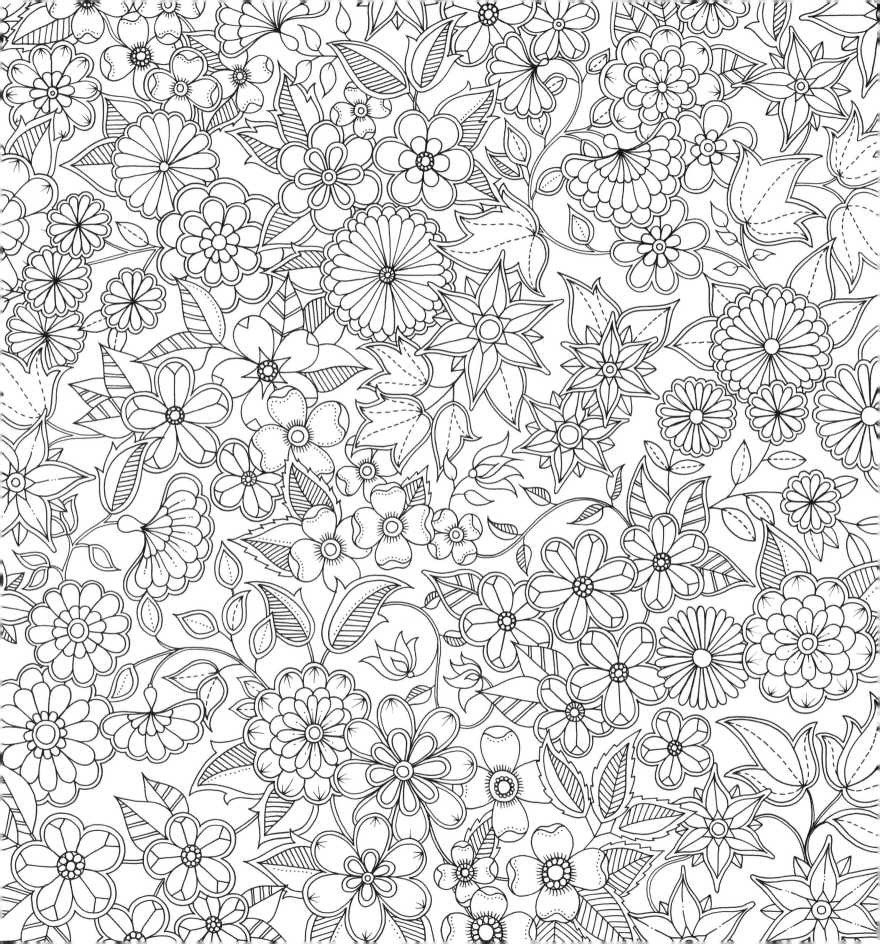

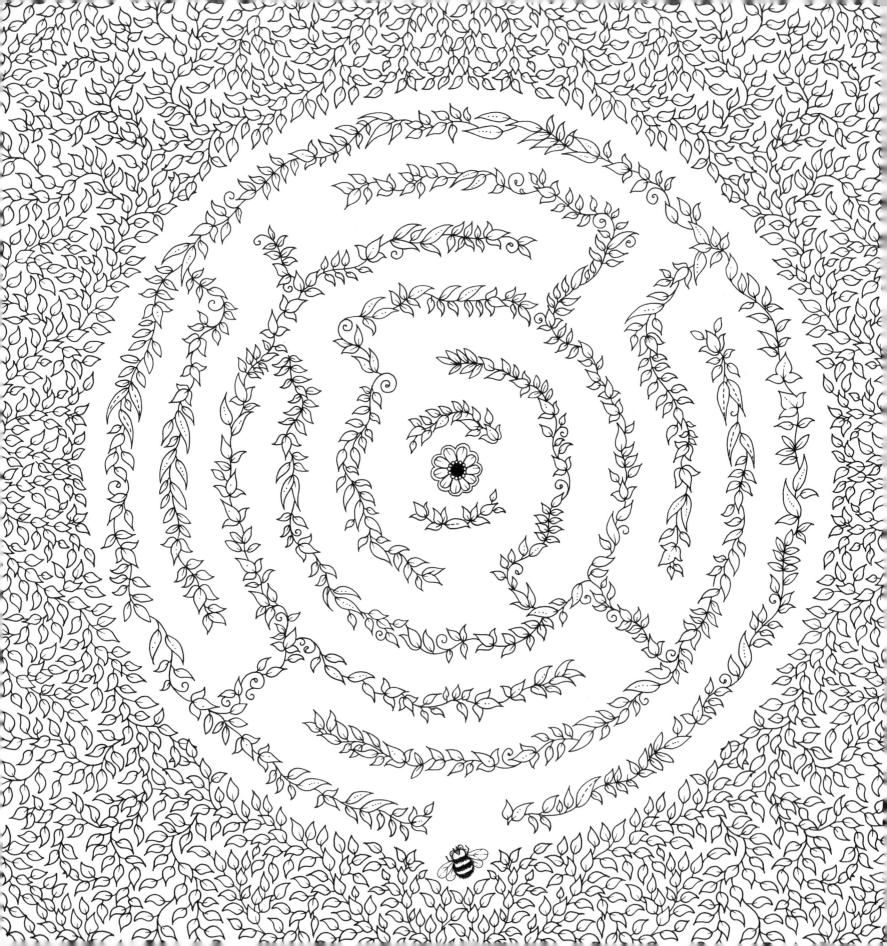

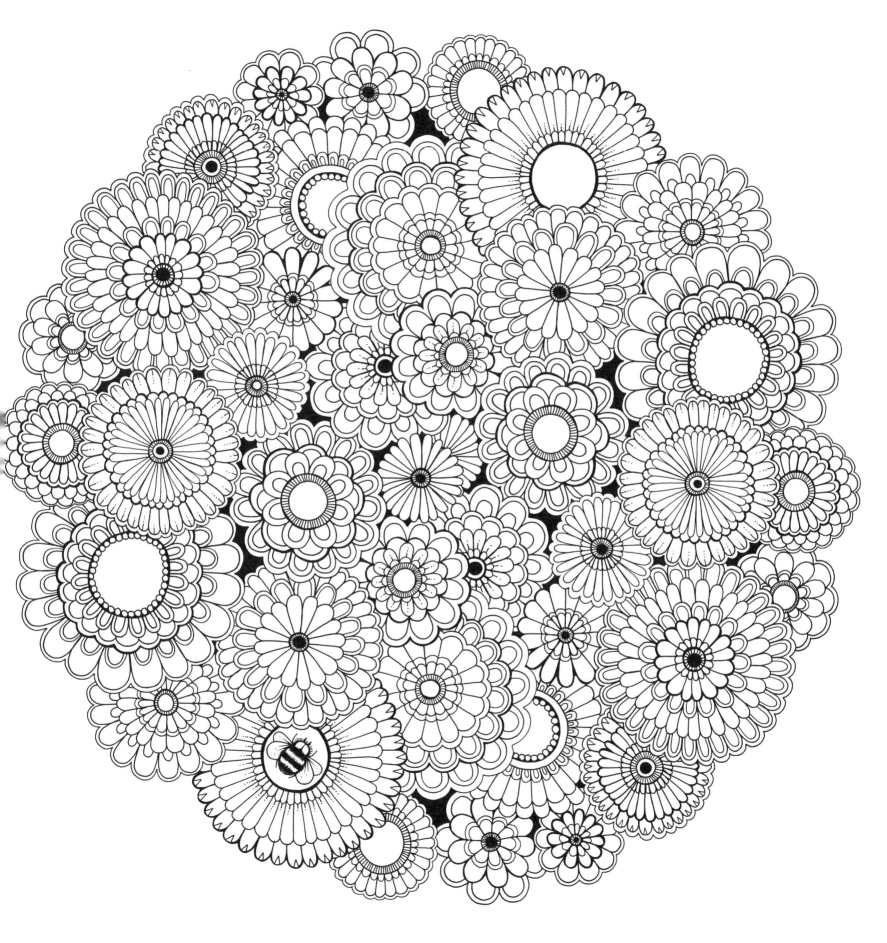

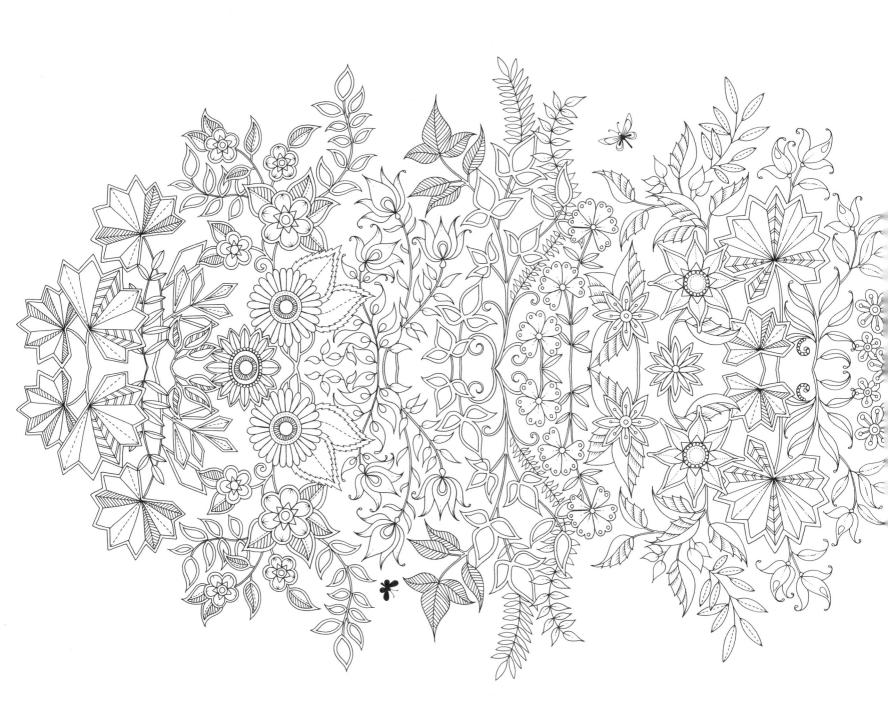

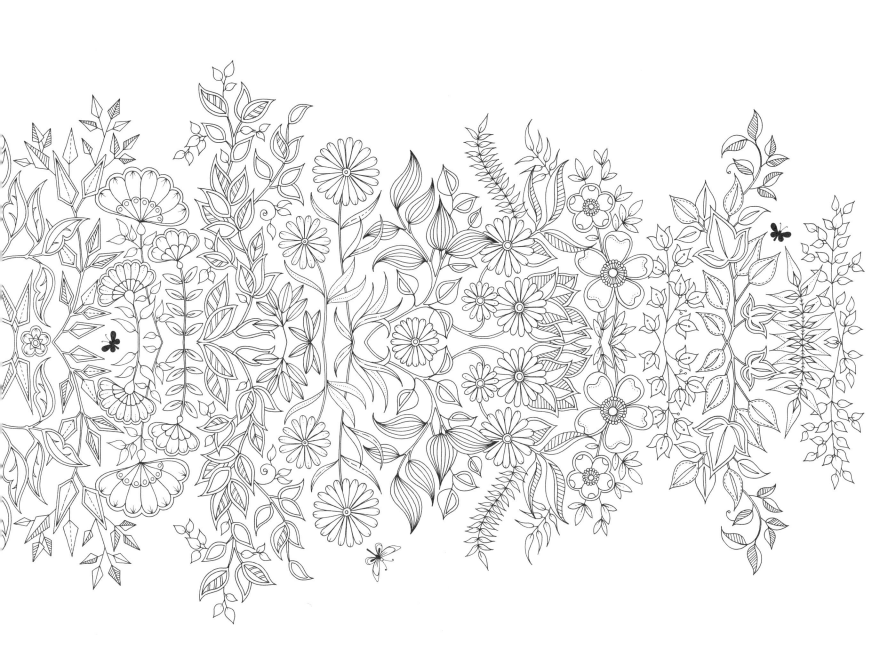

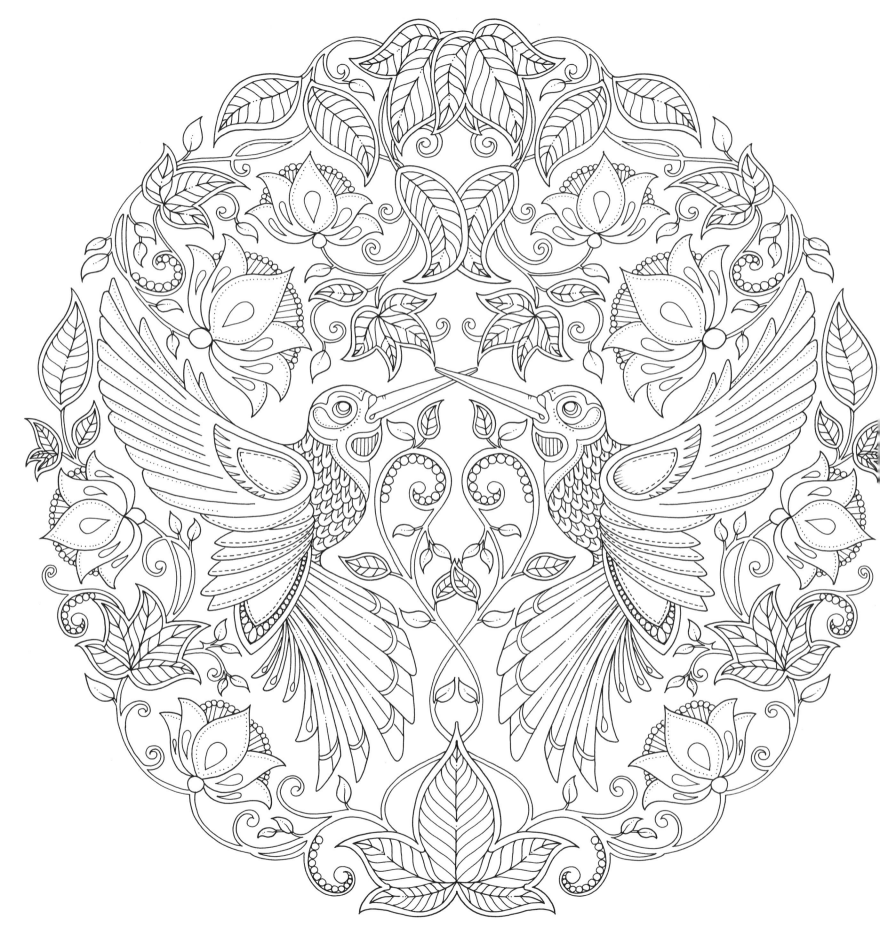

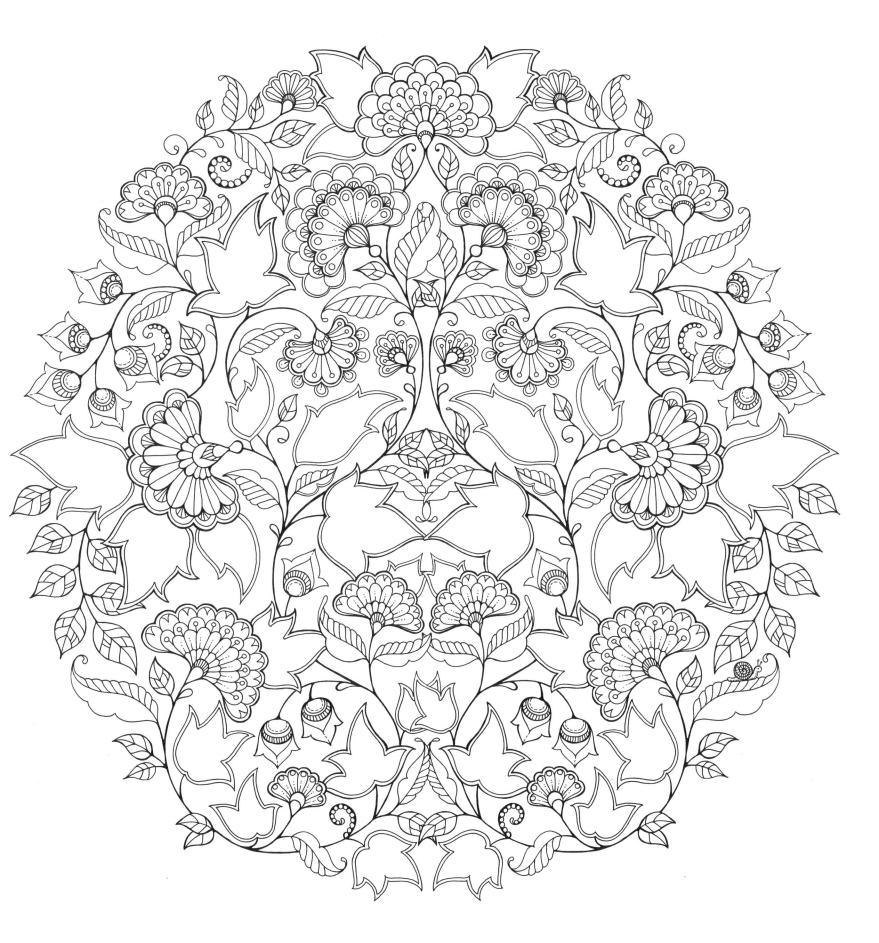

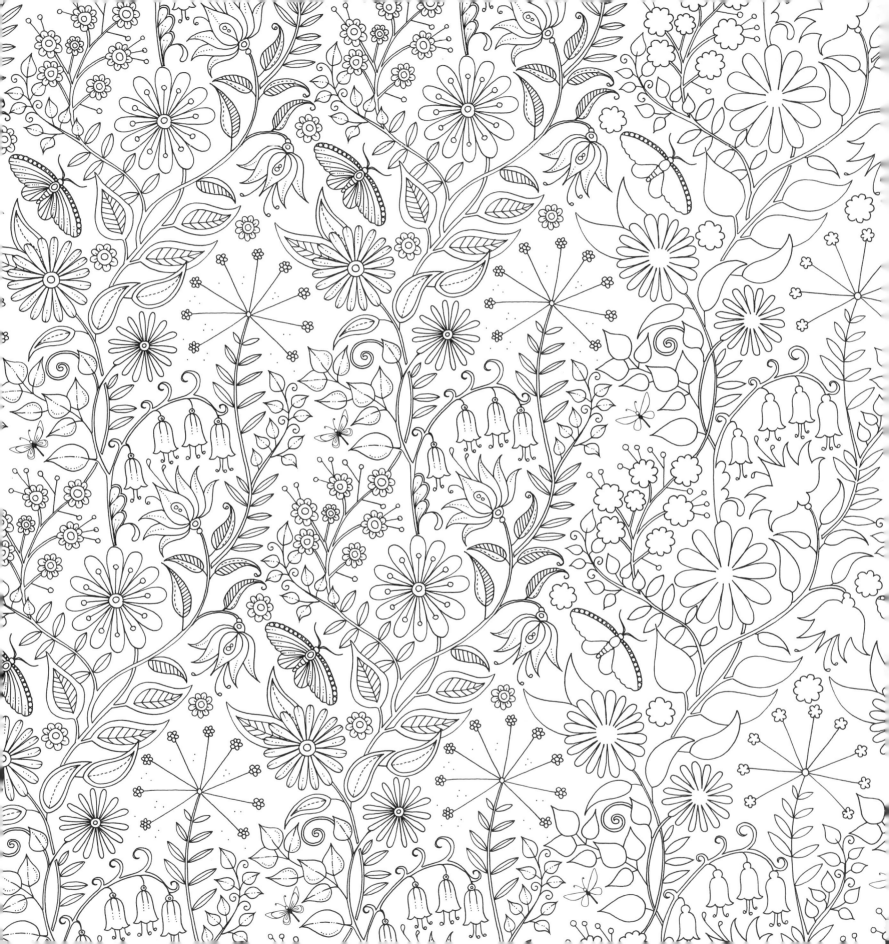

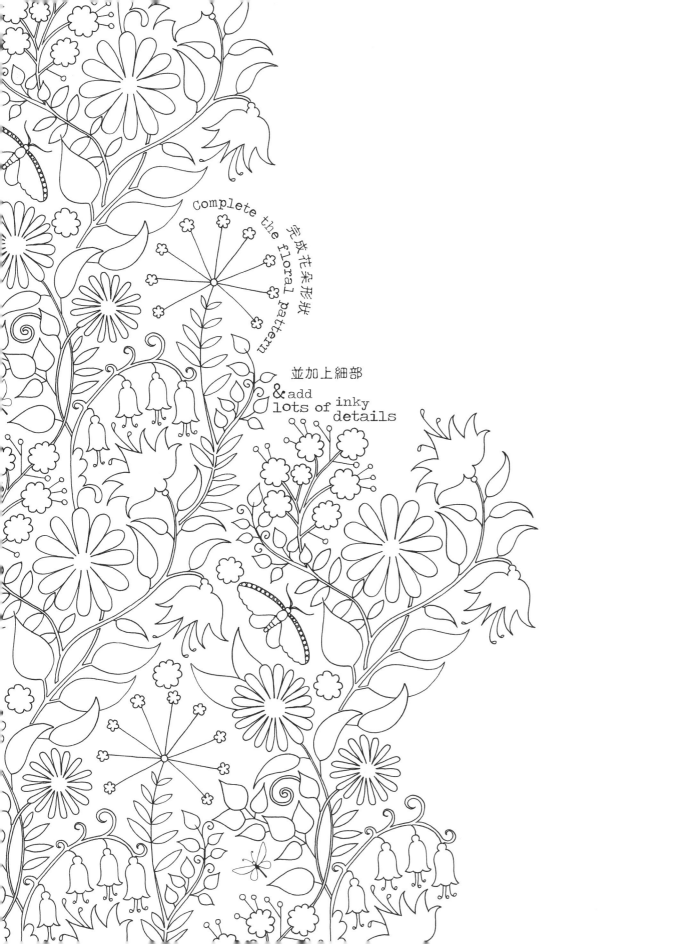

Complete the floral pattern

完成花朵形狀

並加上細部
& add
lots of inky details

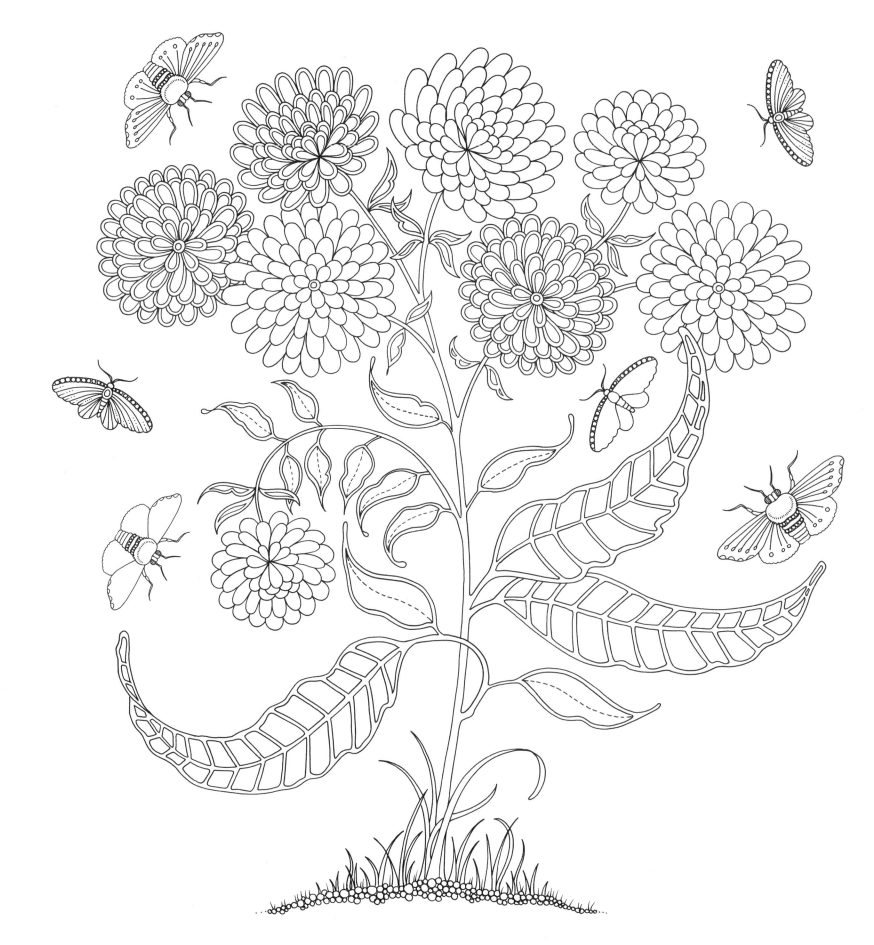

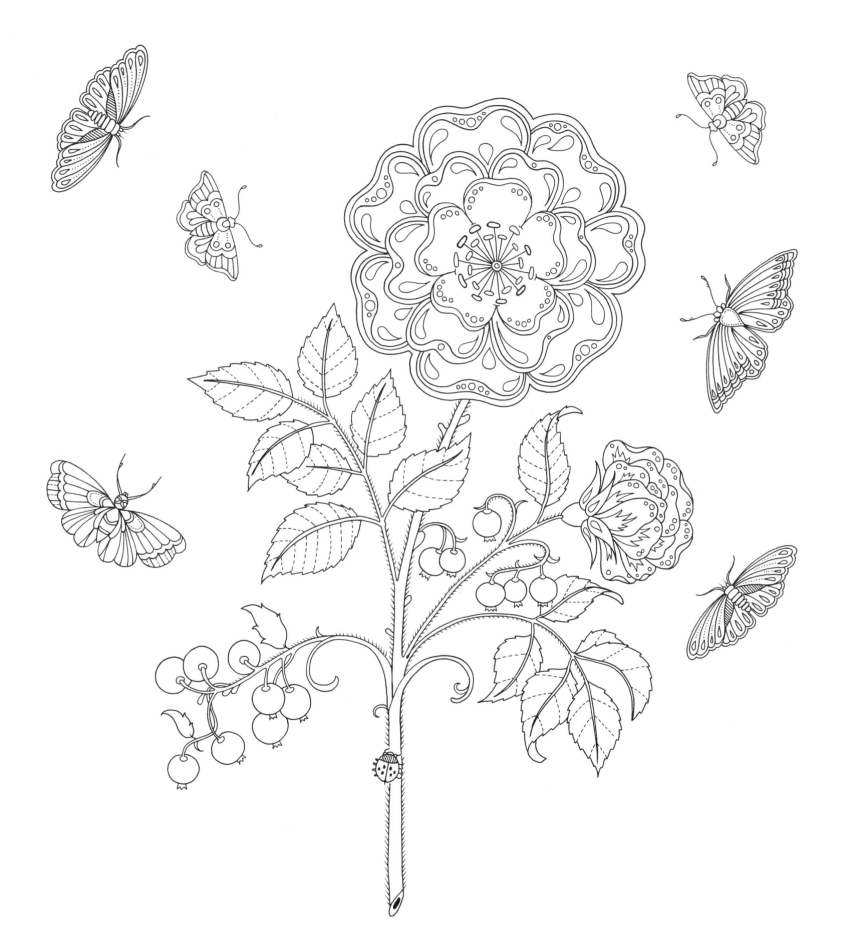

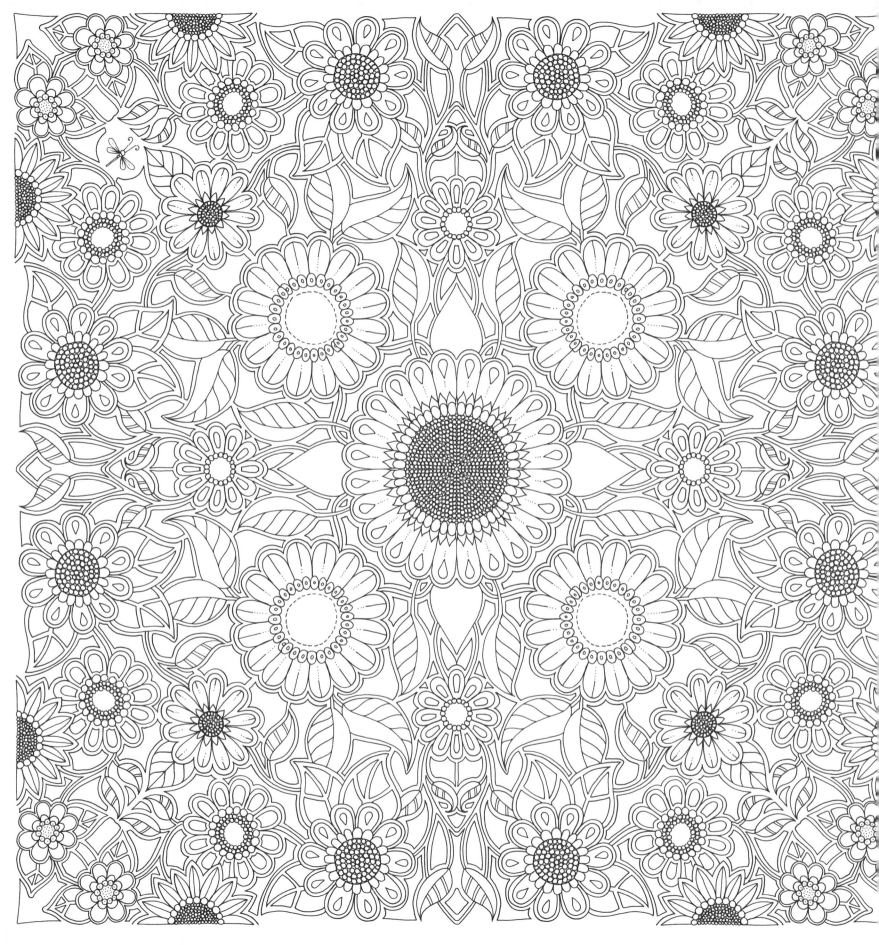

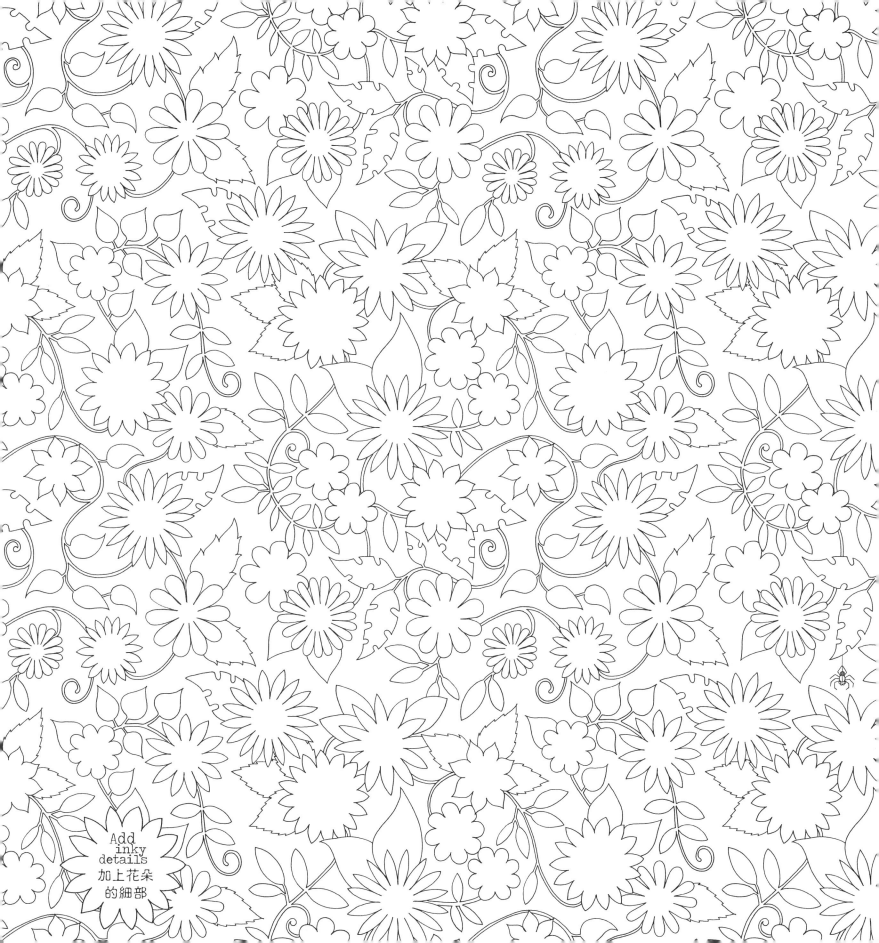

Add
inky
details
加上花朵
的細部

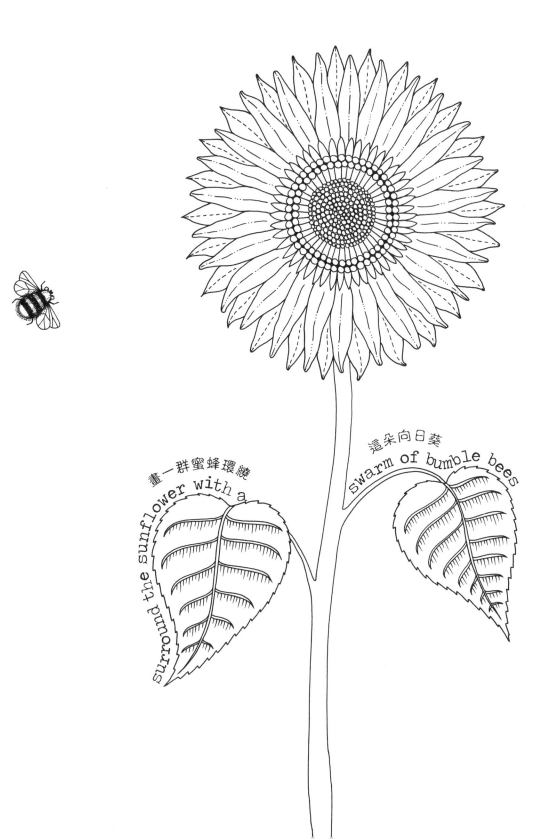

這朵向日葵

畫一群蜜蜂環繞

Surround the sunflower with a

swarm of bumble bees

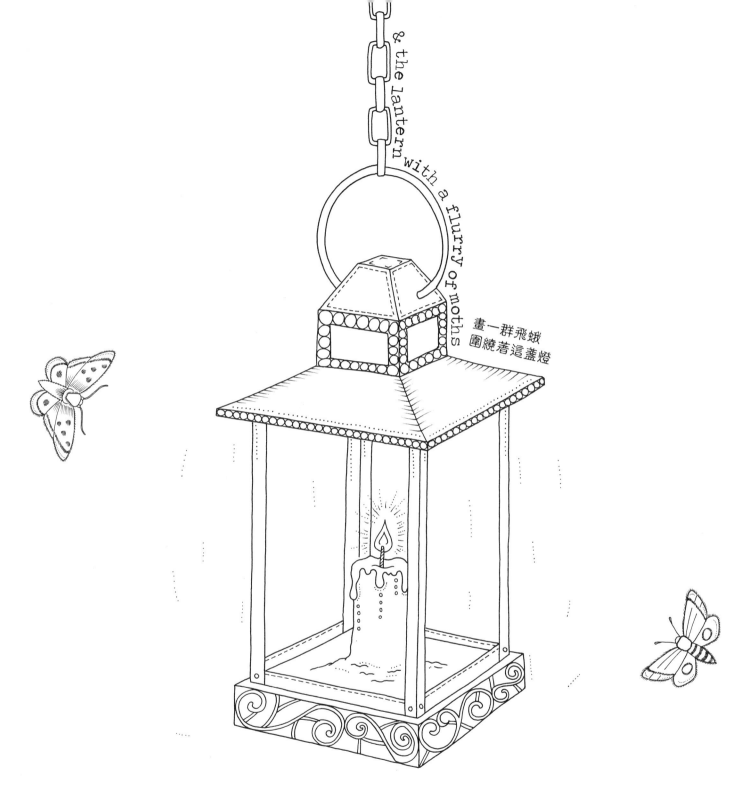

& the lantern with a flurry of moths

畫一群飛蛾
圍繞著這盞燈

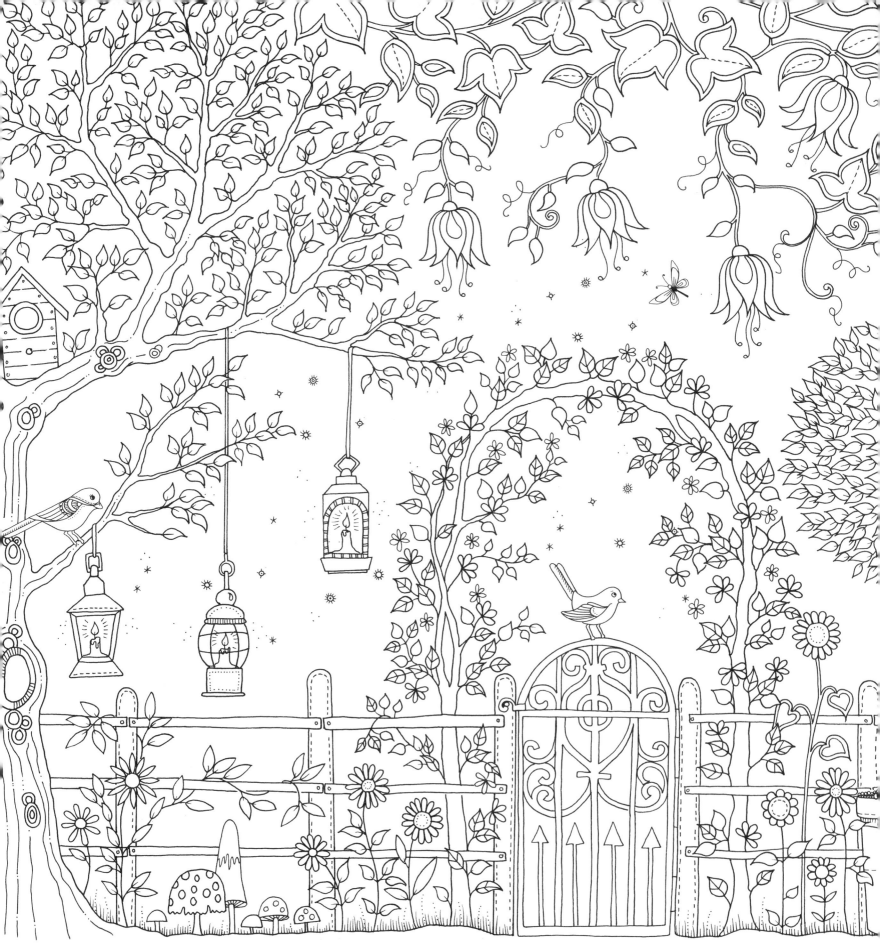

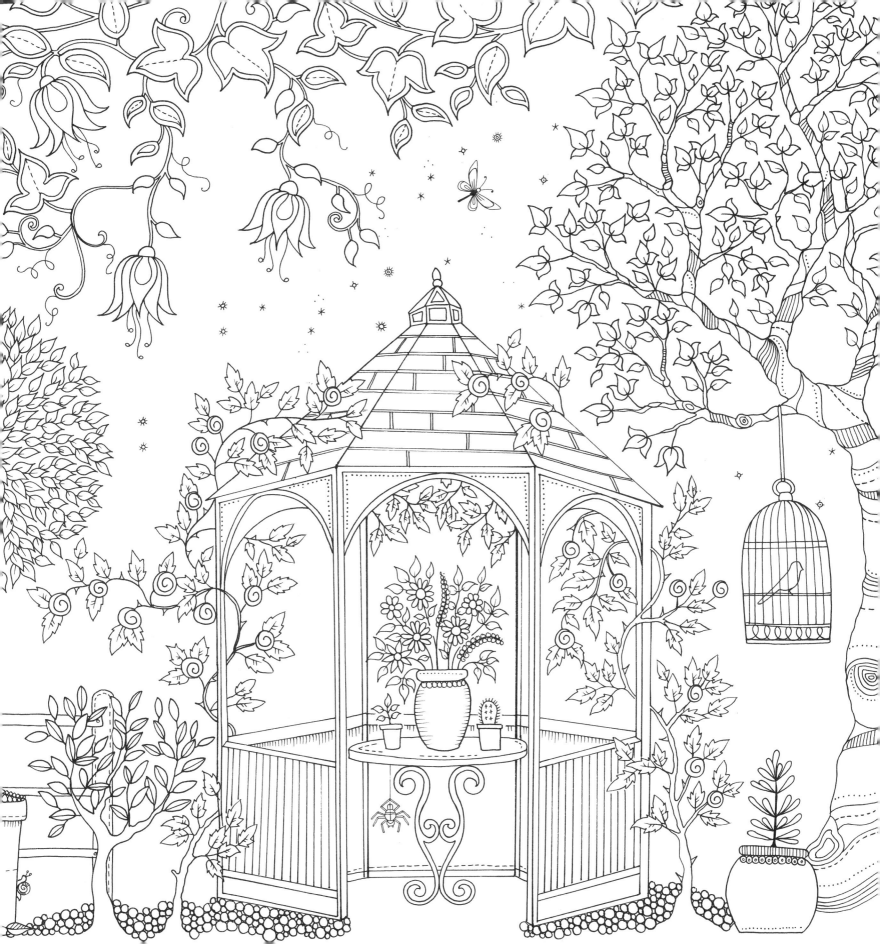

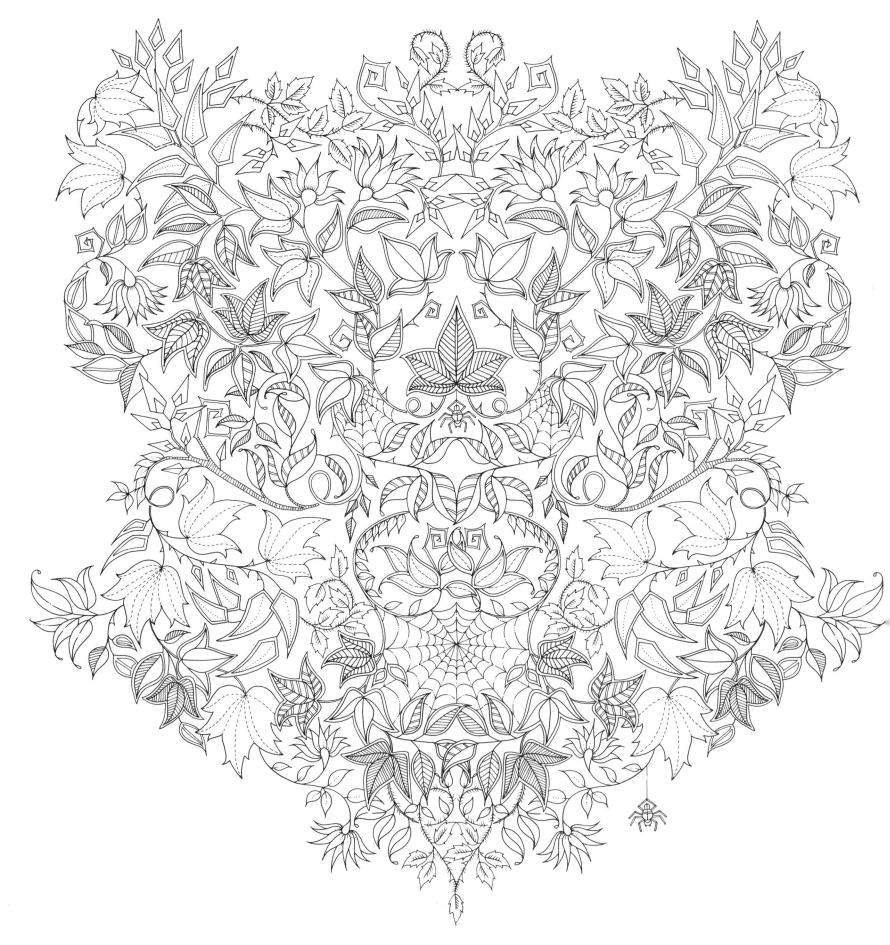

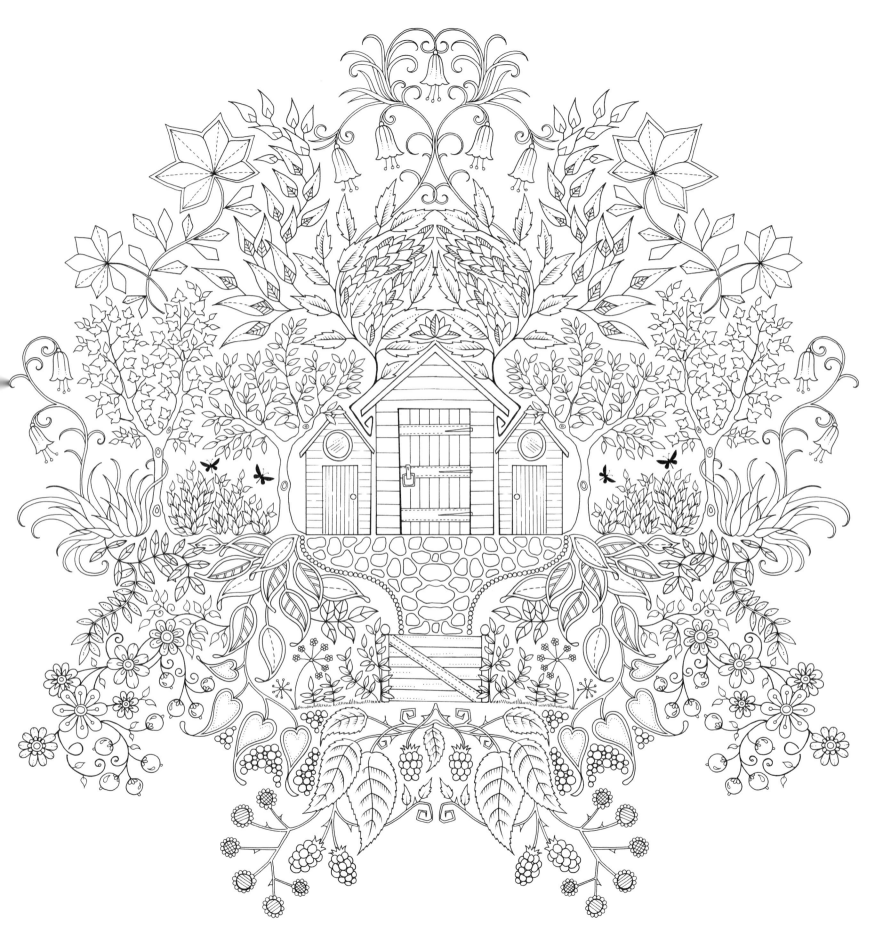

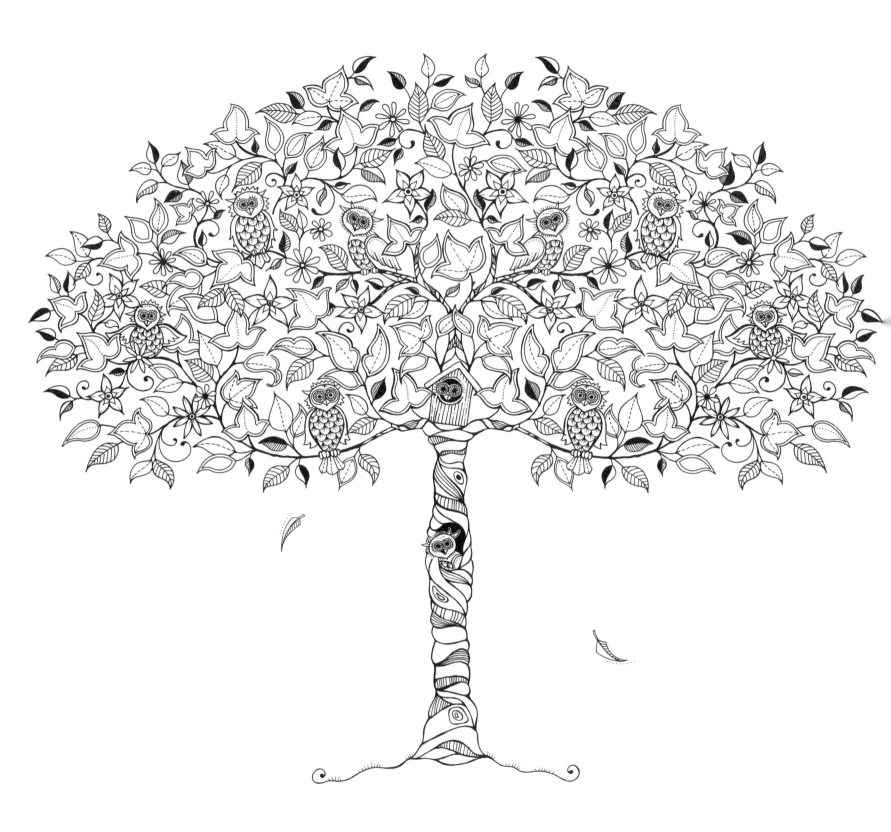

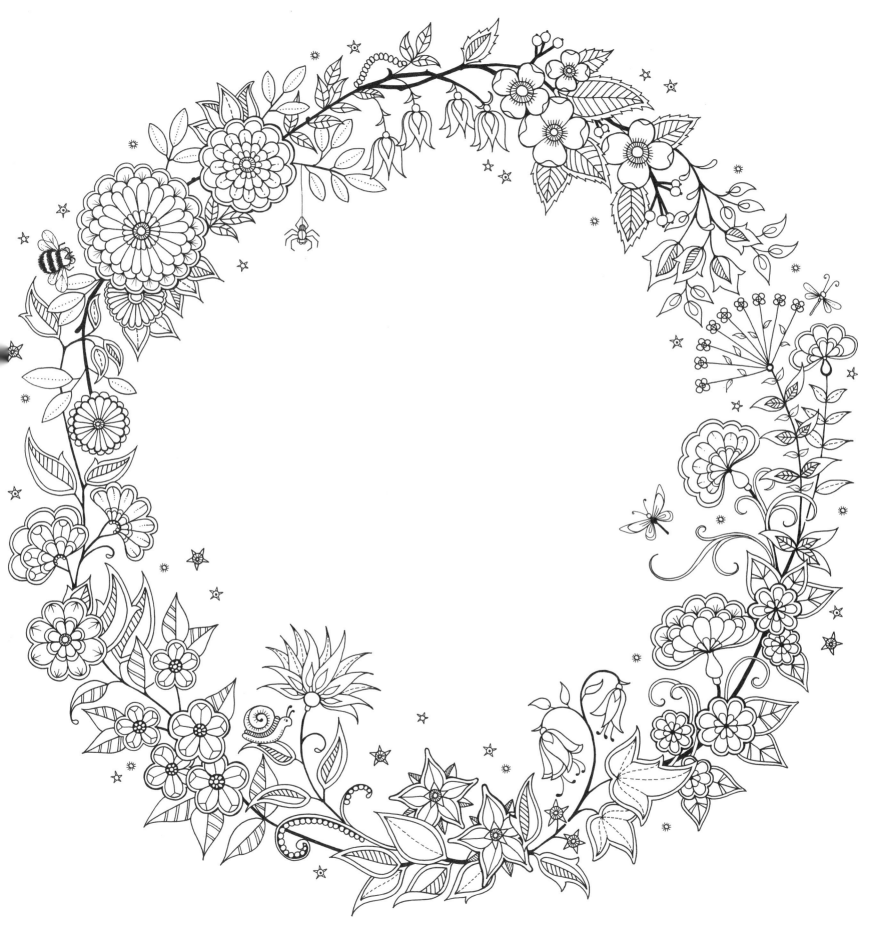

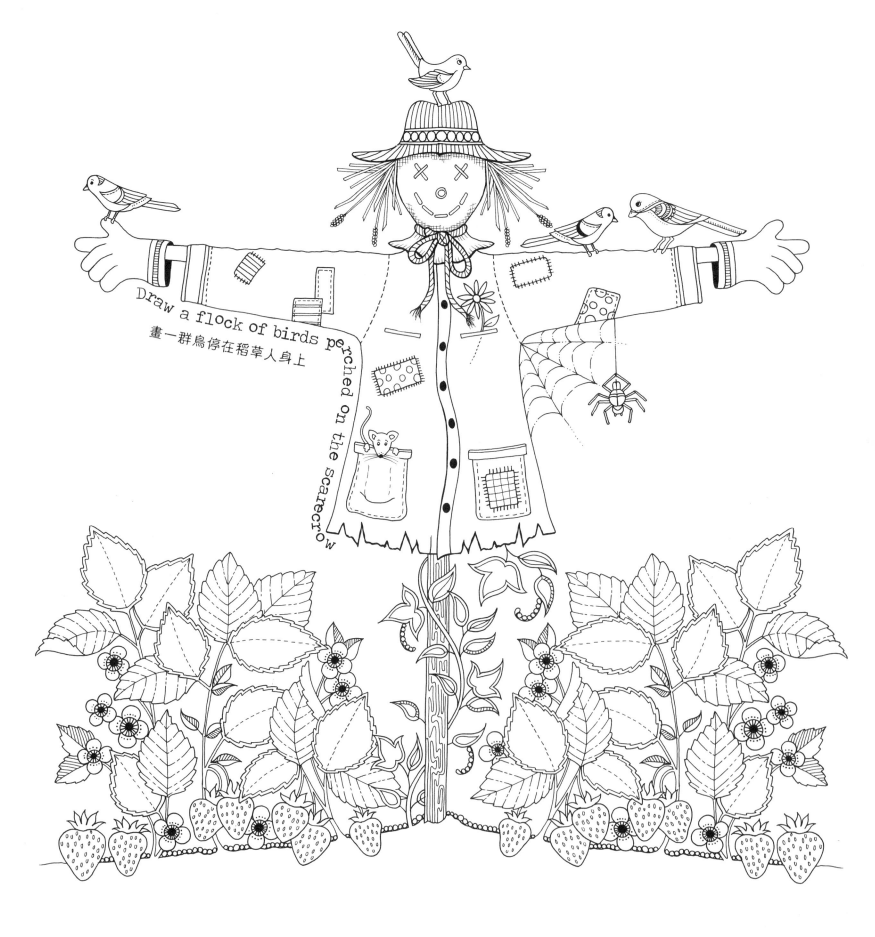

Draw a flock of birds perched on the scarecrow

畫一群鳥停在稻草人身上

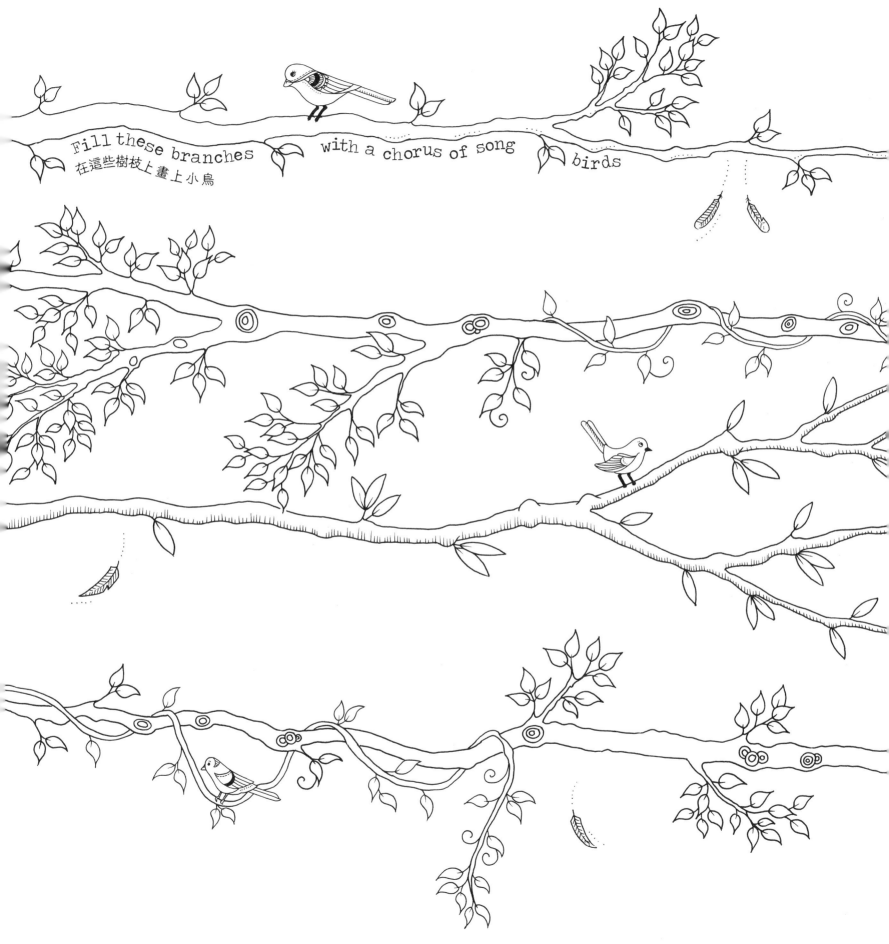

Fill these branches with a chorus of song birds
在這些樹枝上畫上小鳥

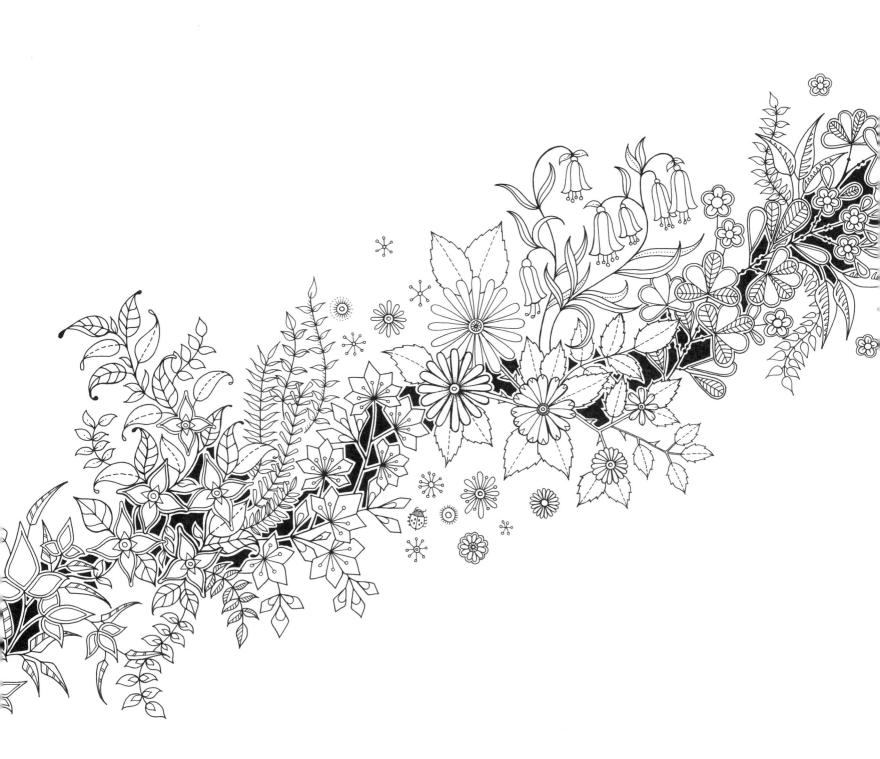

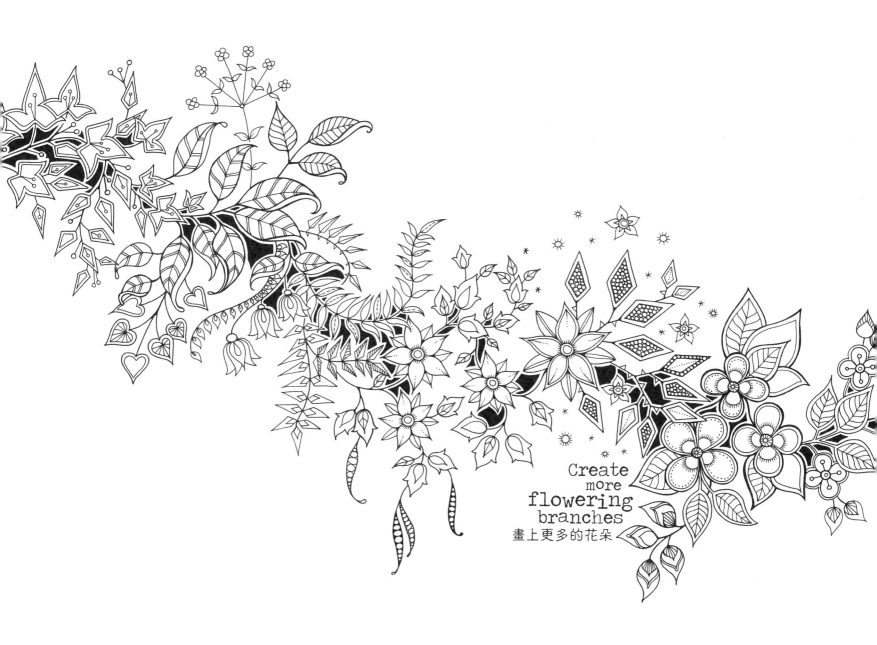

Create
more
flowering
branches
畫上更多的花朵

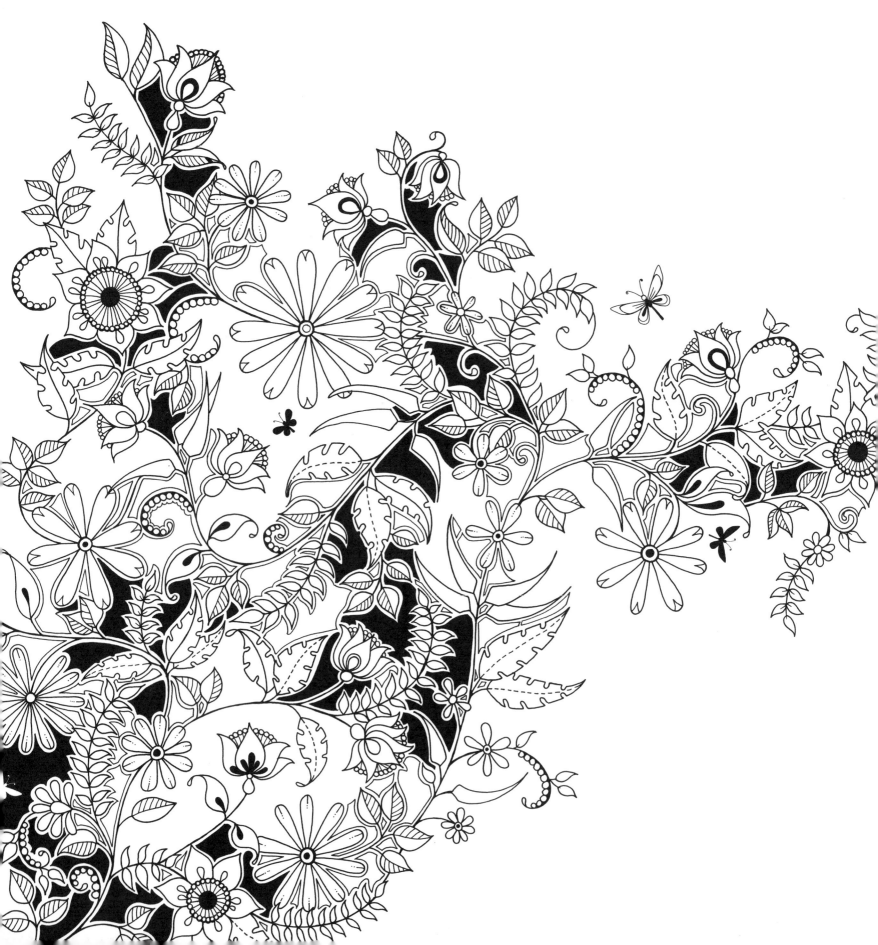

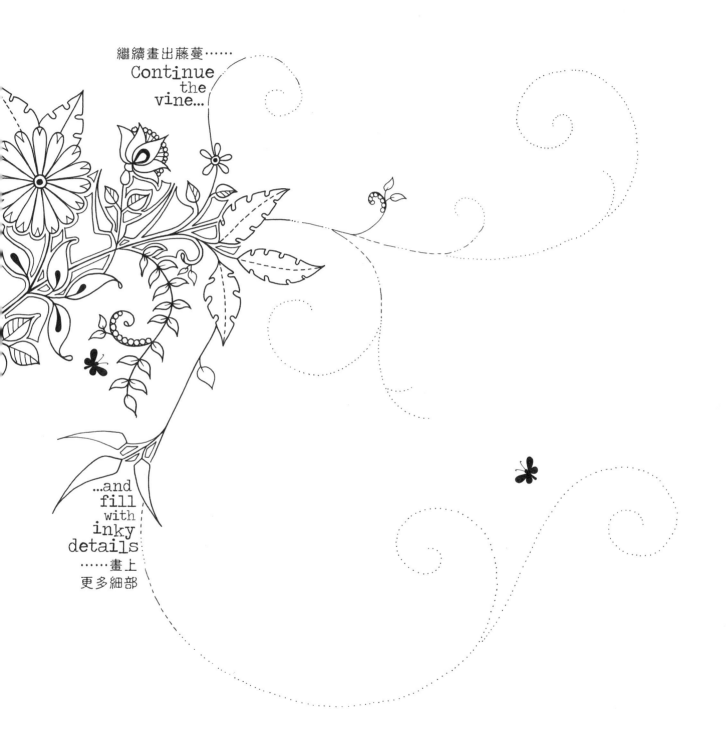

繼續畫出藤蔓……

Continue the vine...

...and fill with inky details

……畫上更多細部

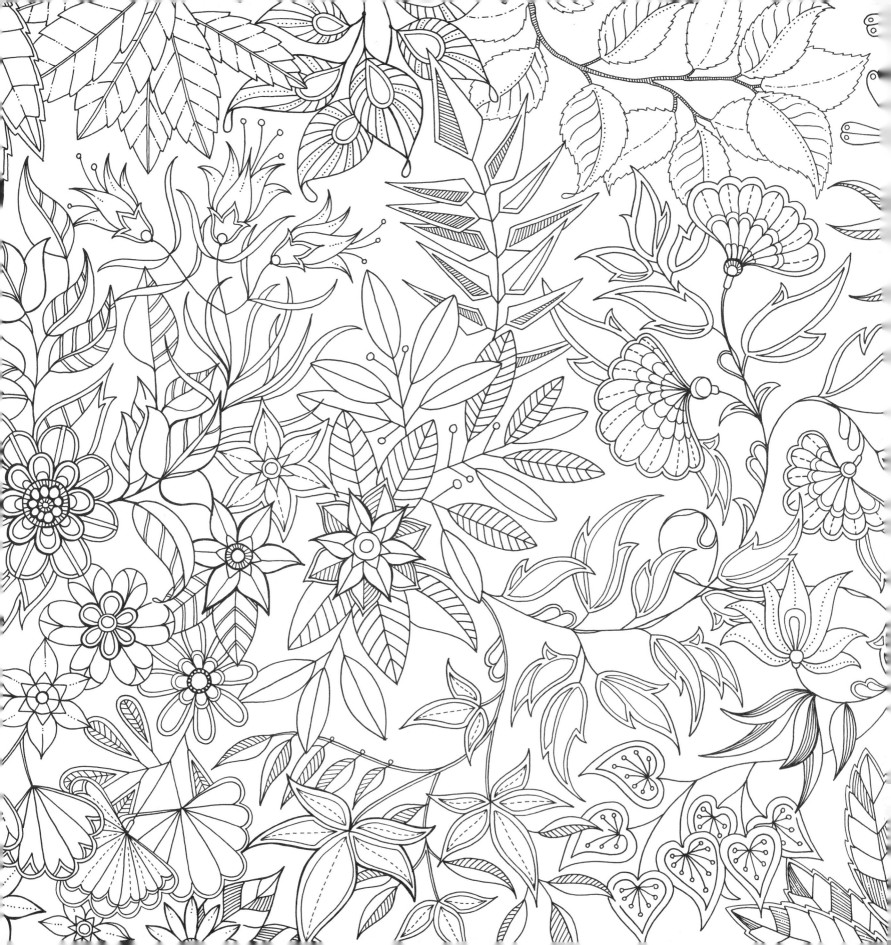

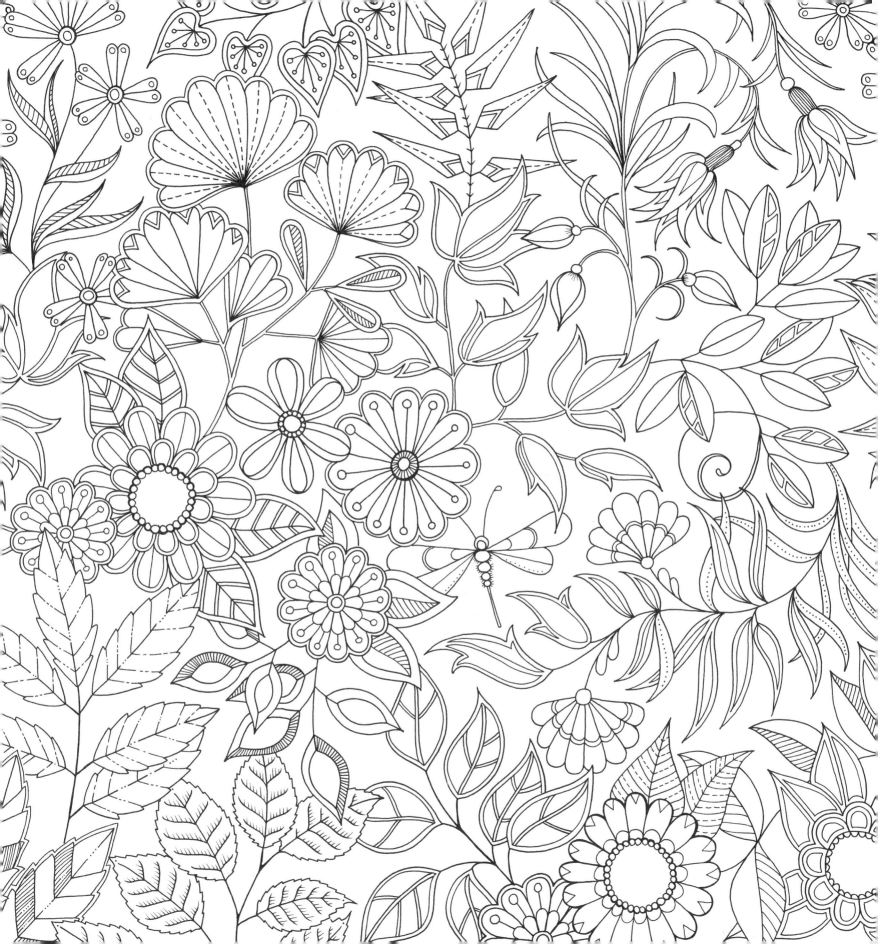

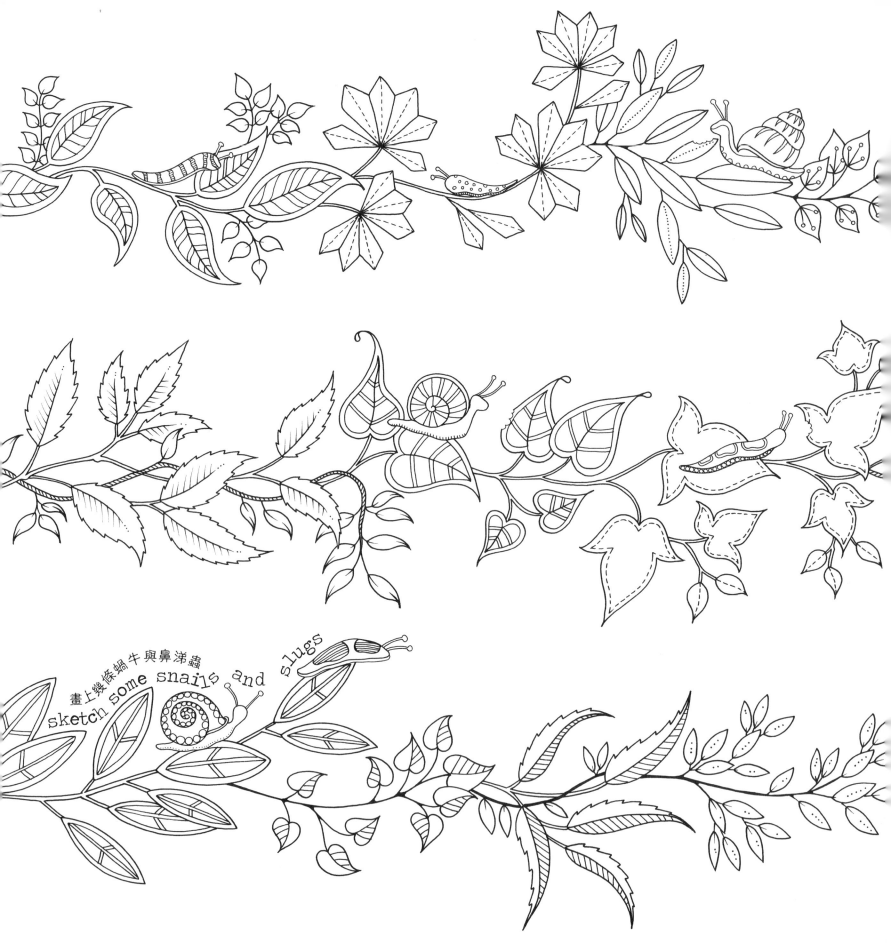

畫上幾條蝸牛與鼻涕蟲
sketch some snails and slugs

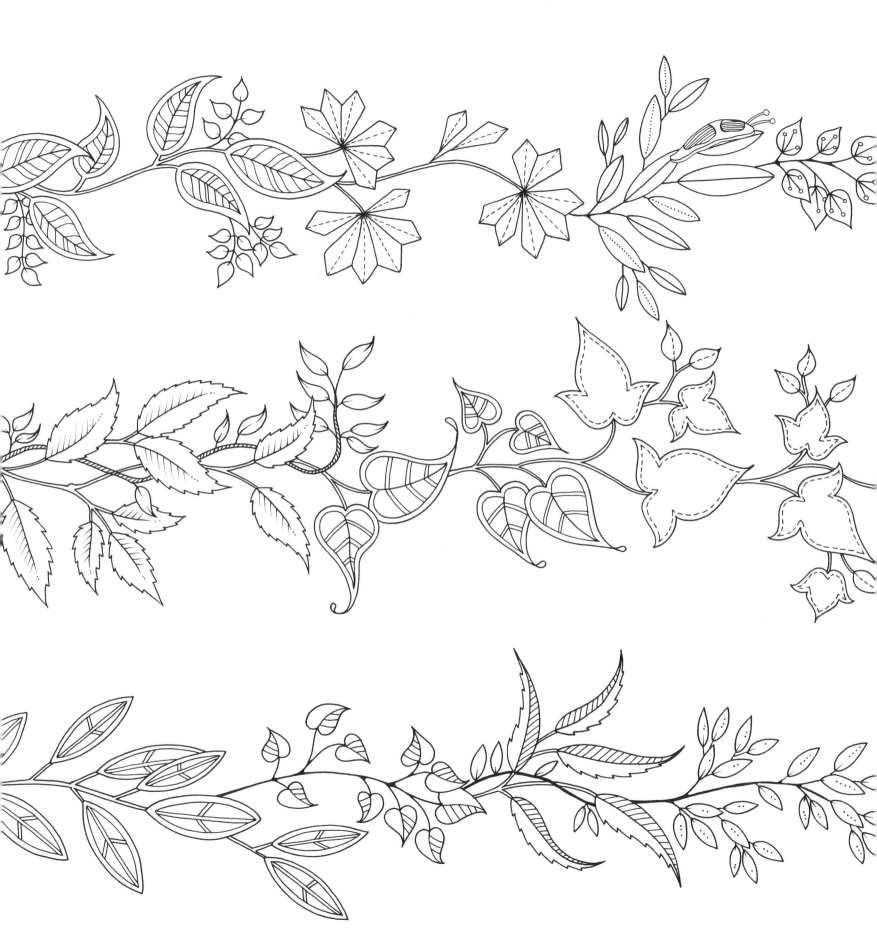

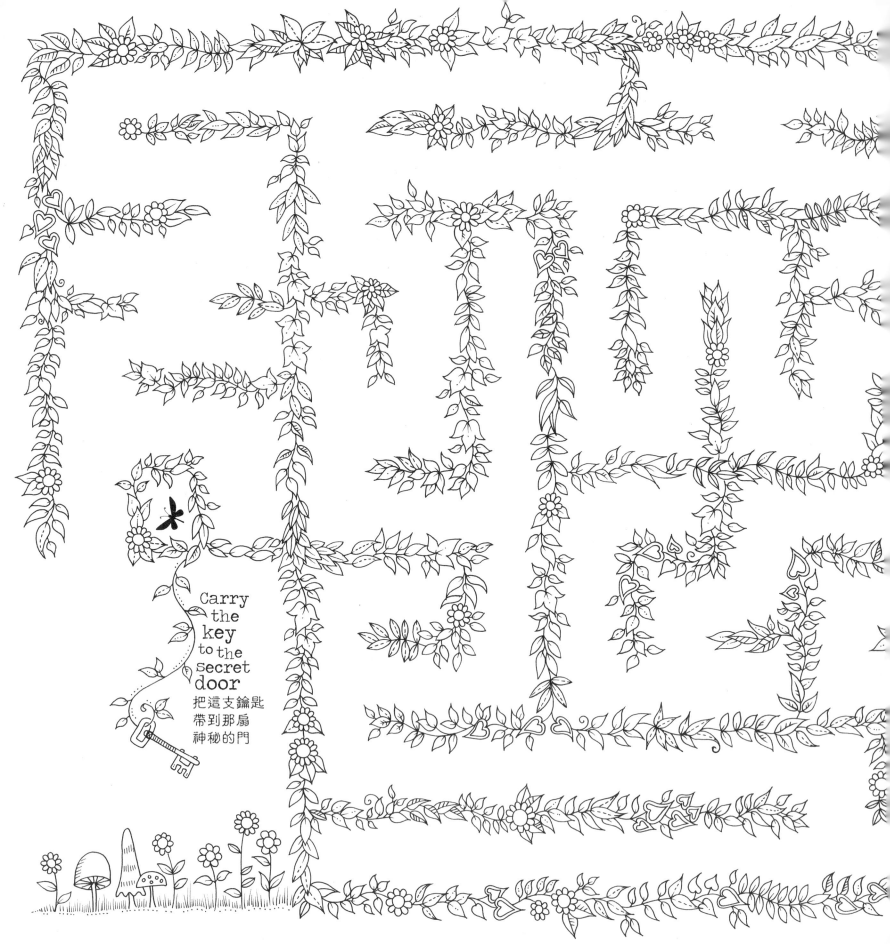

Carry
the
key
to the
secret
door
把這支鑰匙
帶到那扇
神秘的門

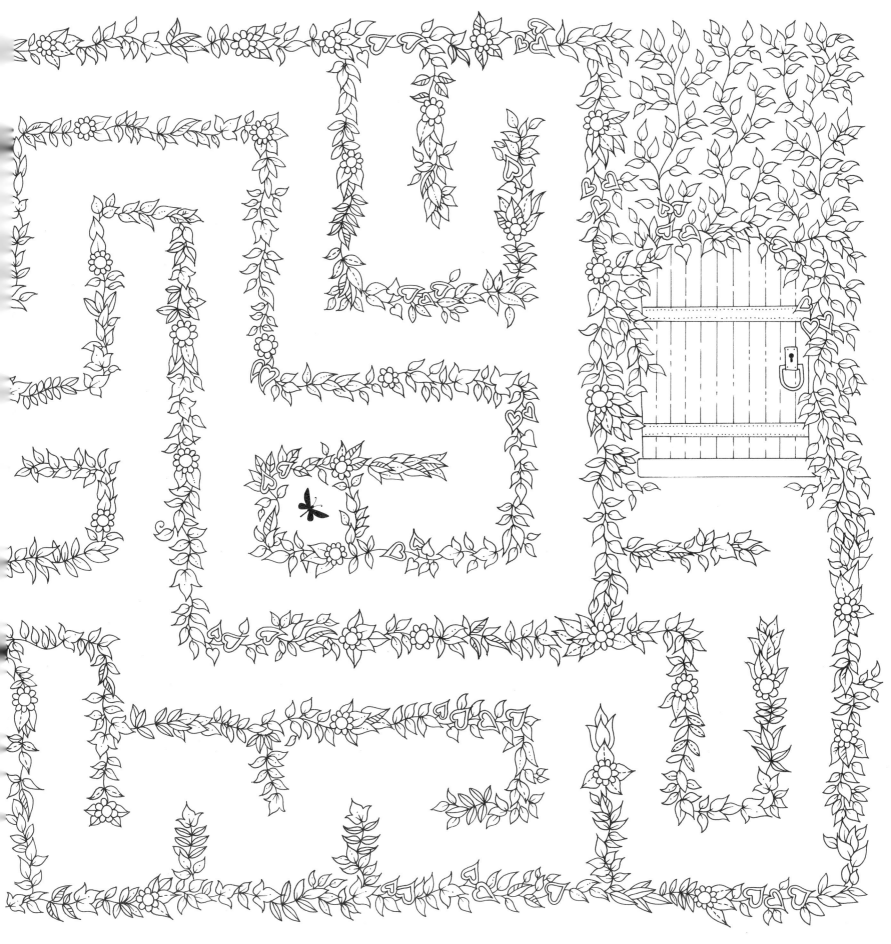

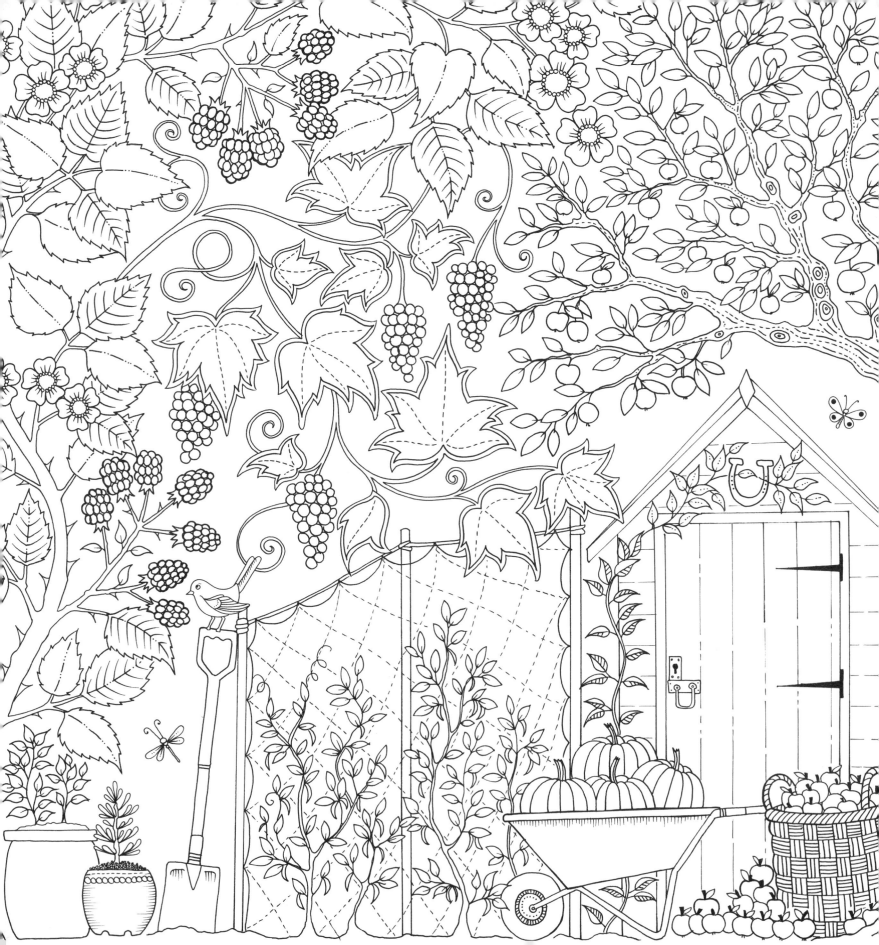

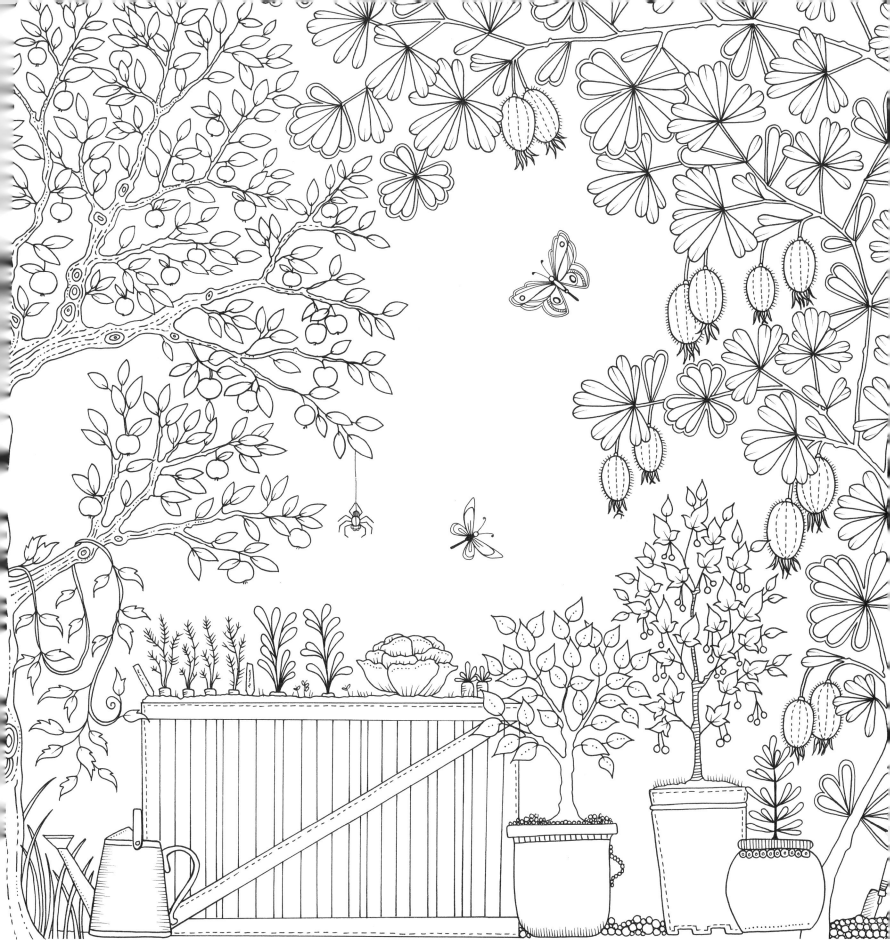

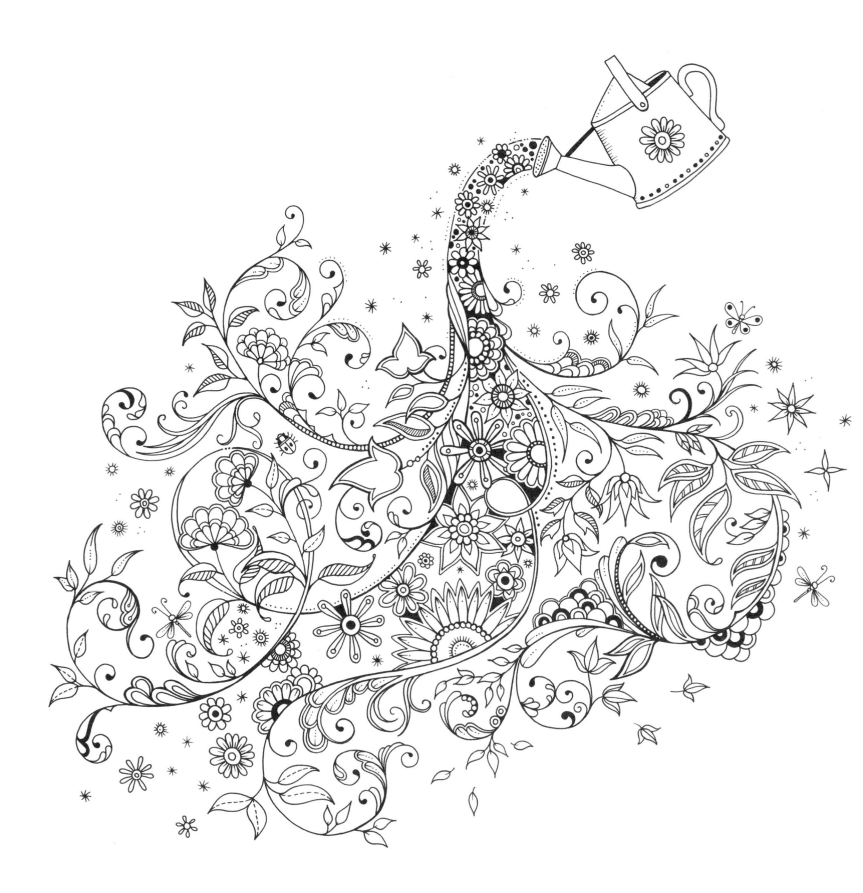

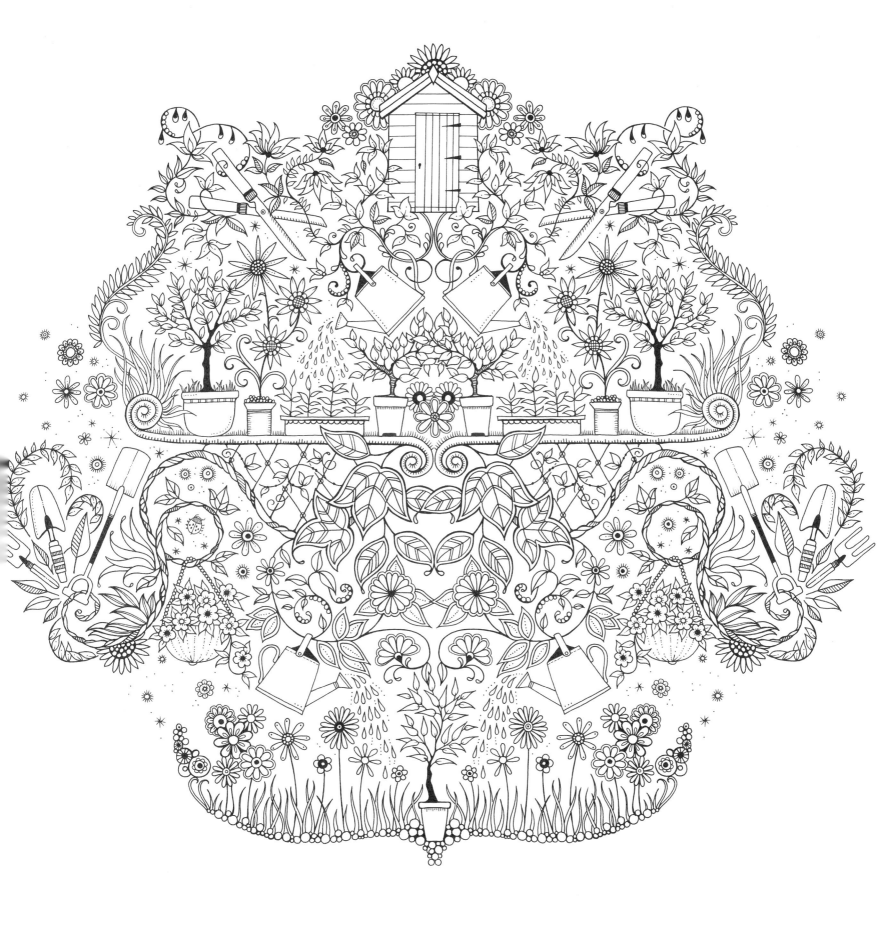

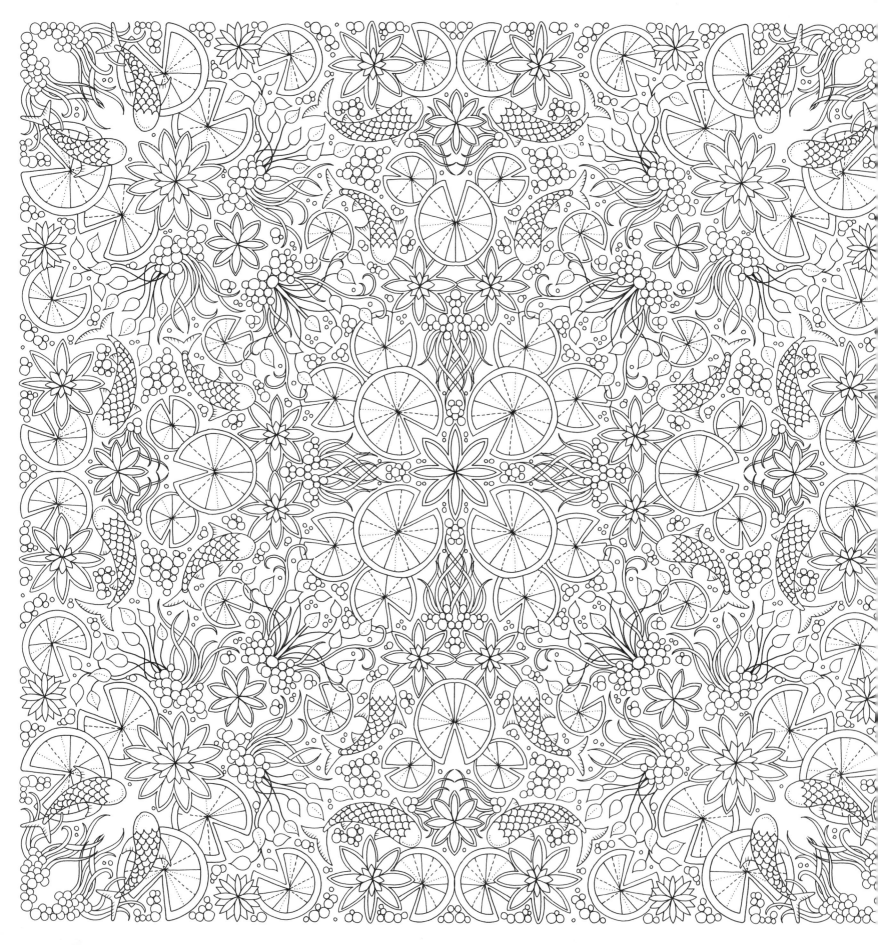

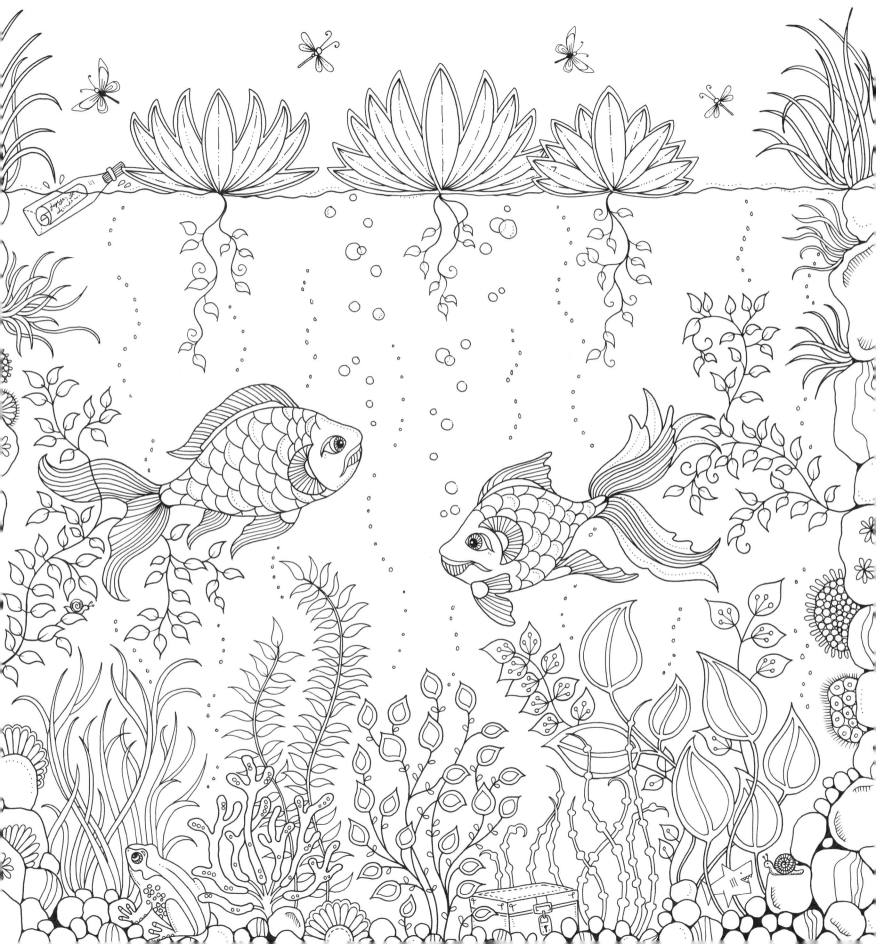

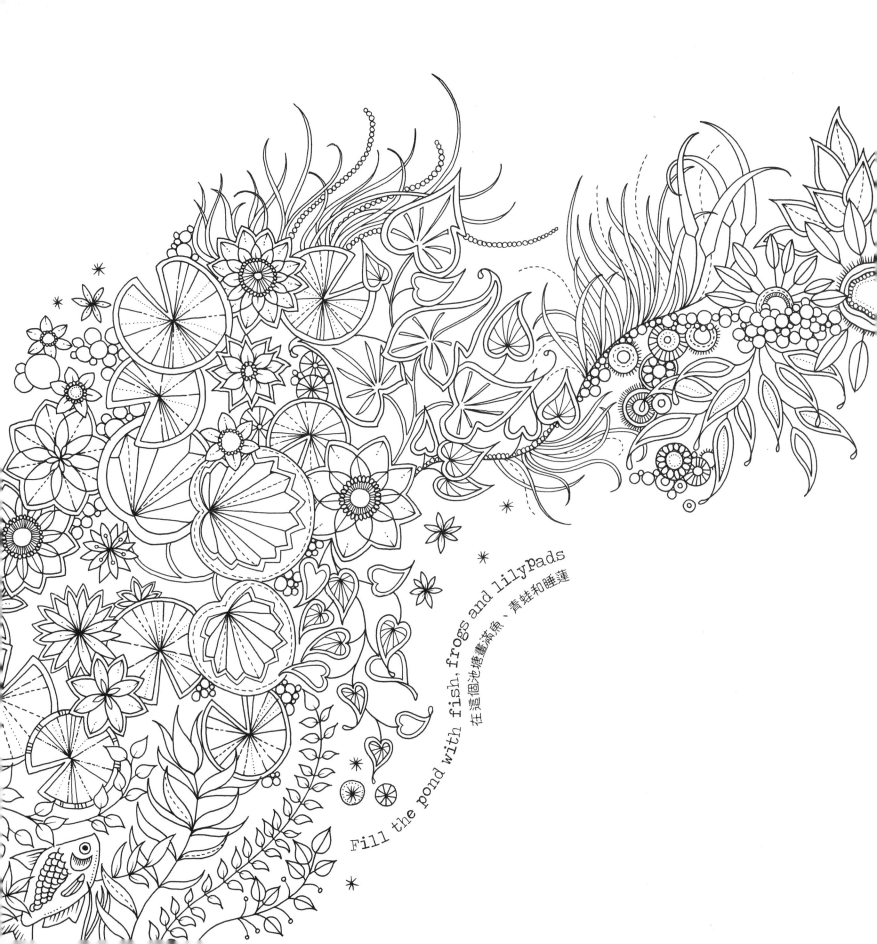

Fill the pond with fish, frogs and lilypads

在這個池塘畫滿魚、青蛙和睡蓮

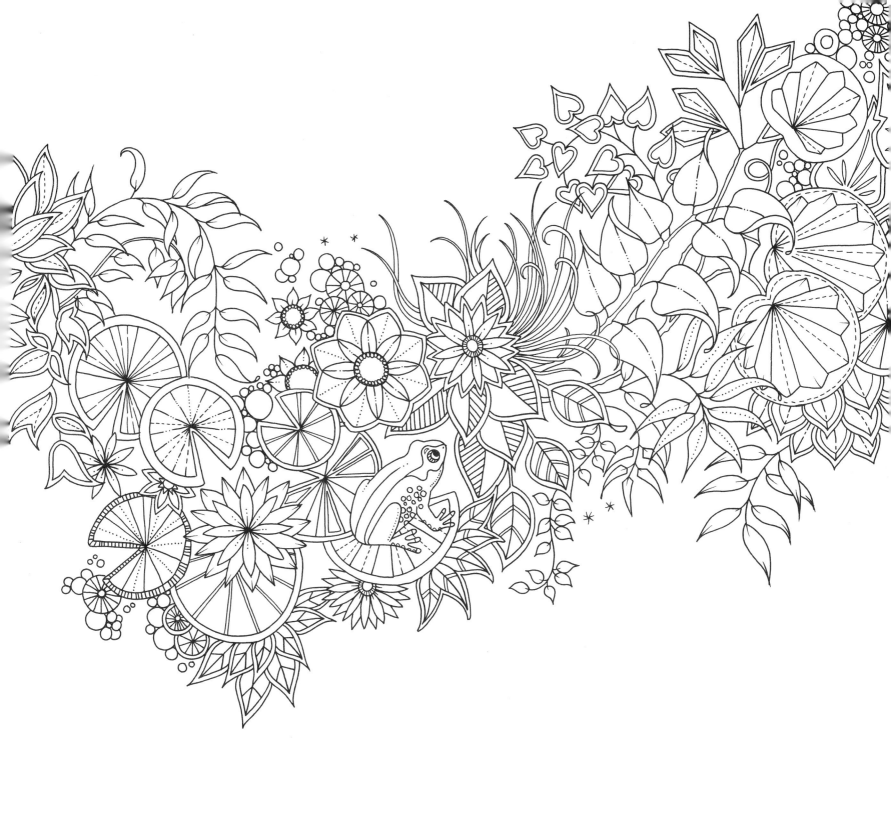

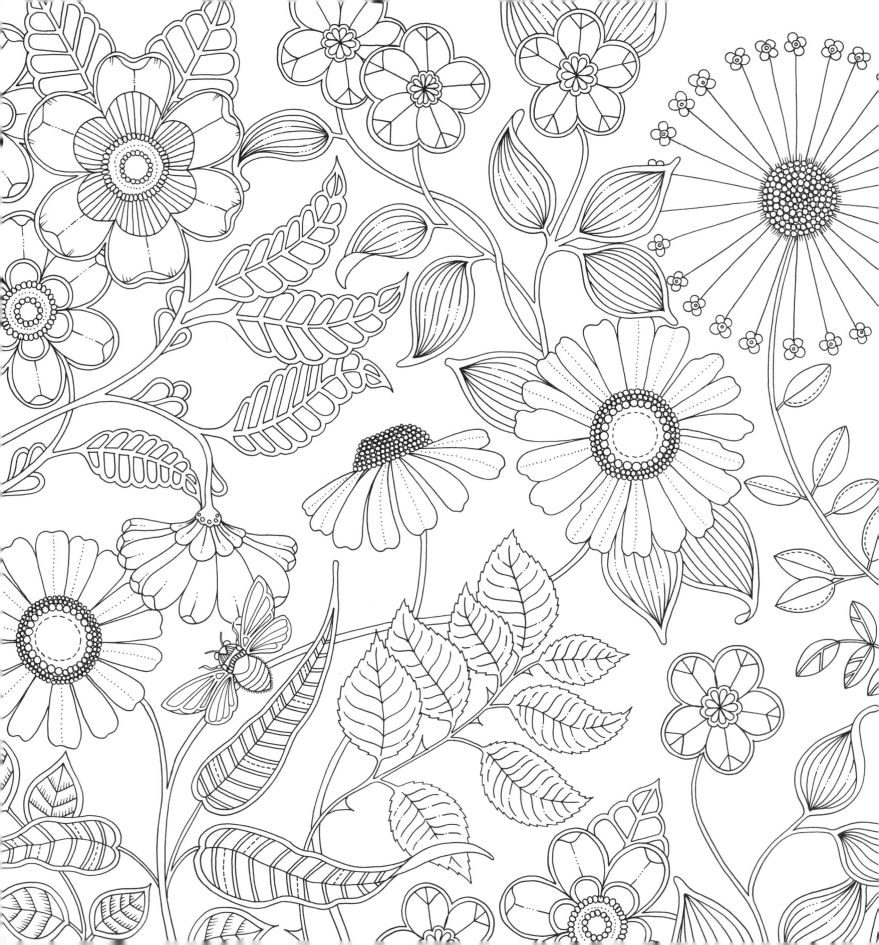

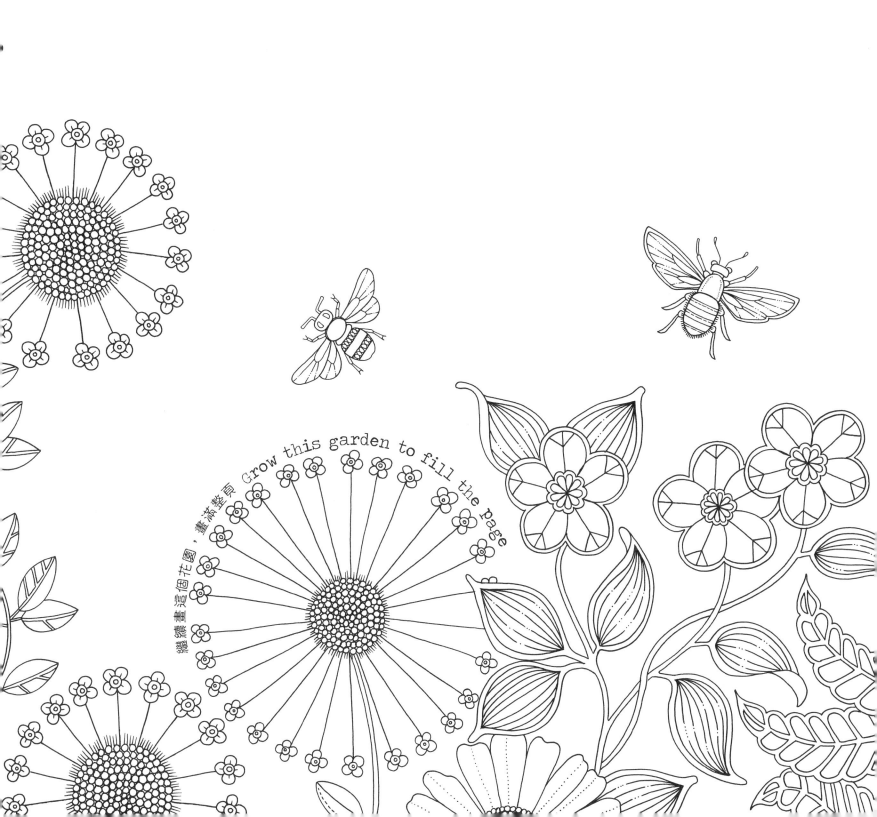

繼續畫這個花園，畫滿整頁 Grow this garden to fill the page

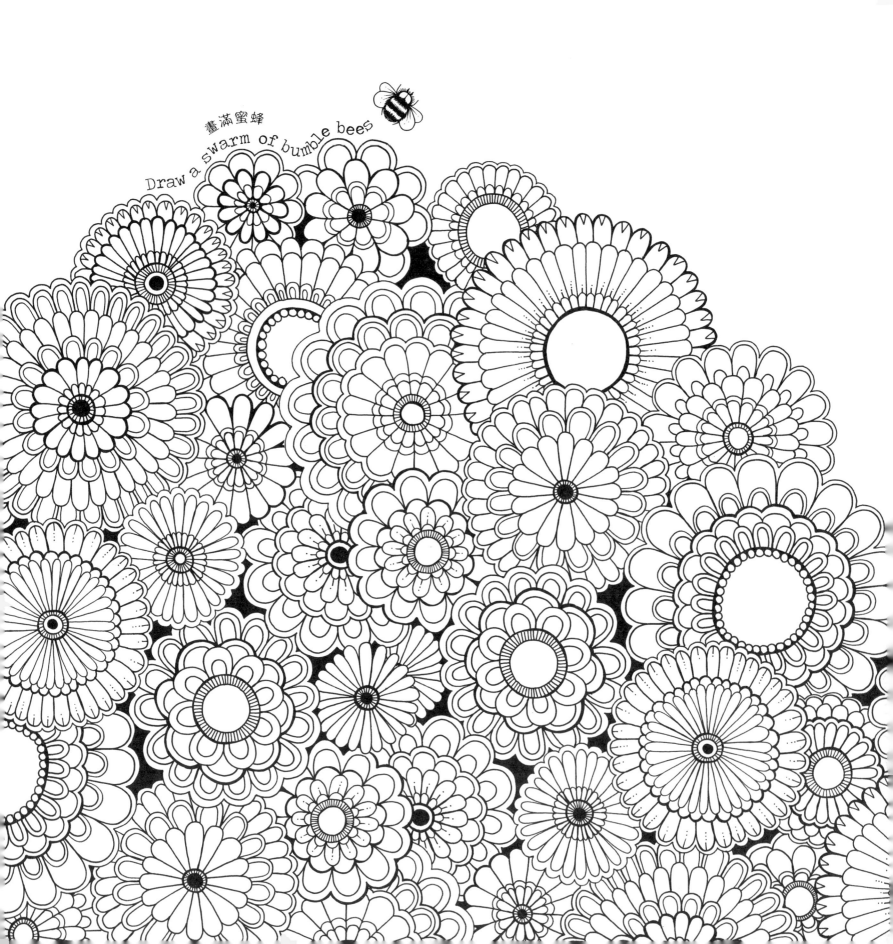

畫滿蜜蜂
Draw a swarm of bumble bees

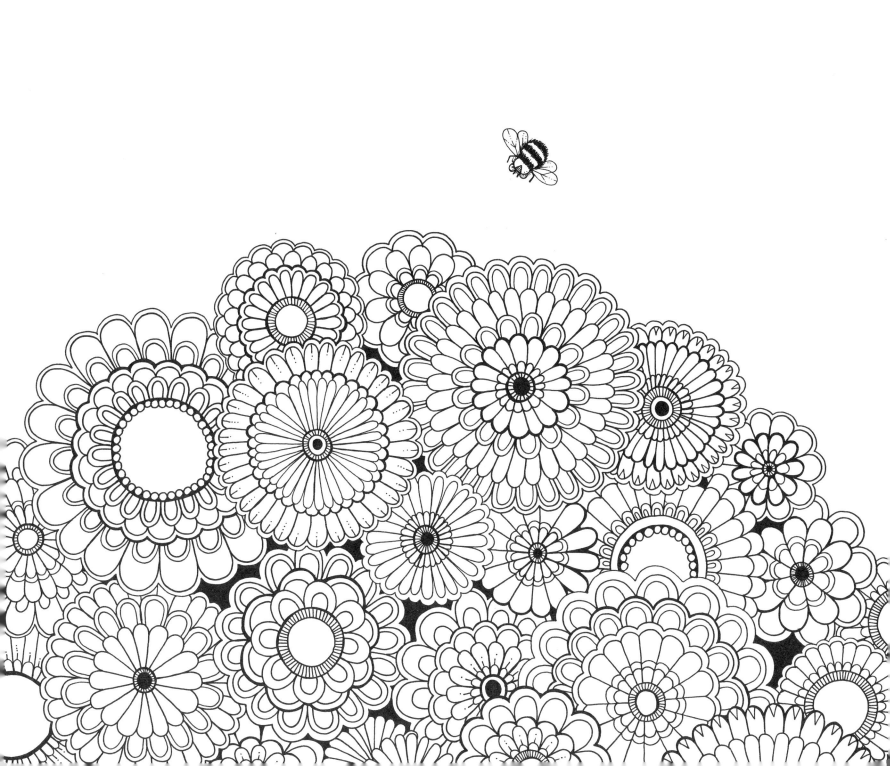

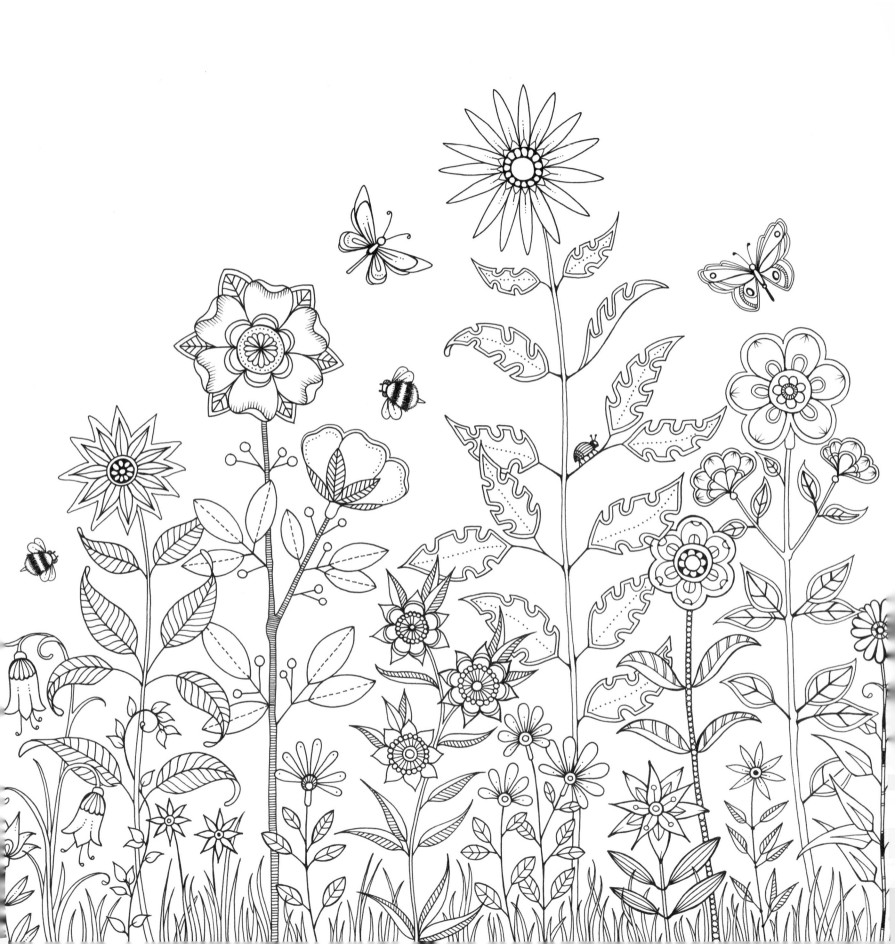

Add pretty inky petals to complete the flower garden

畫上美麗的花瓣，完成這個花園

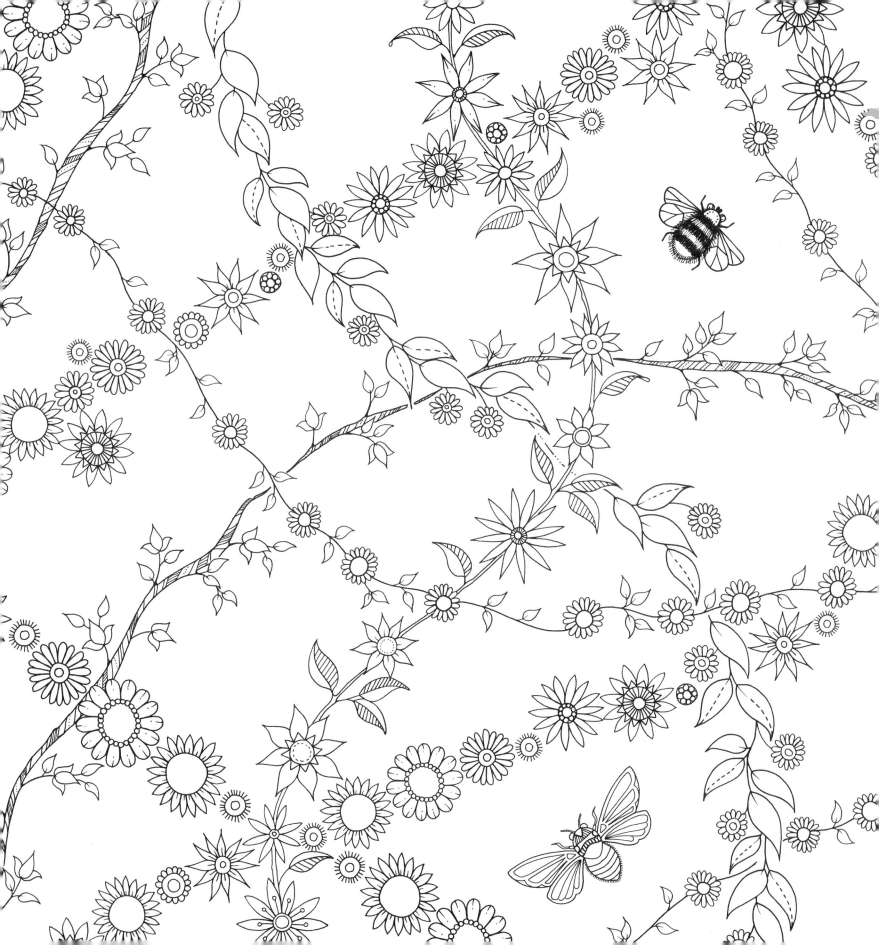

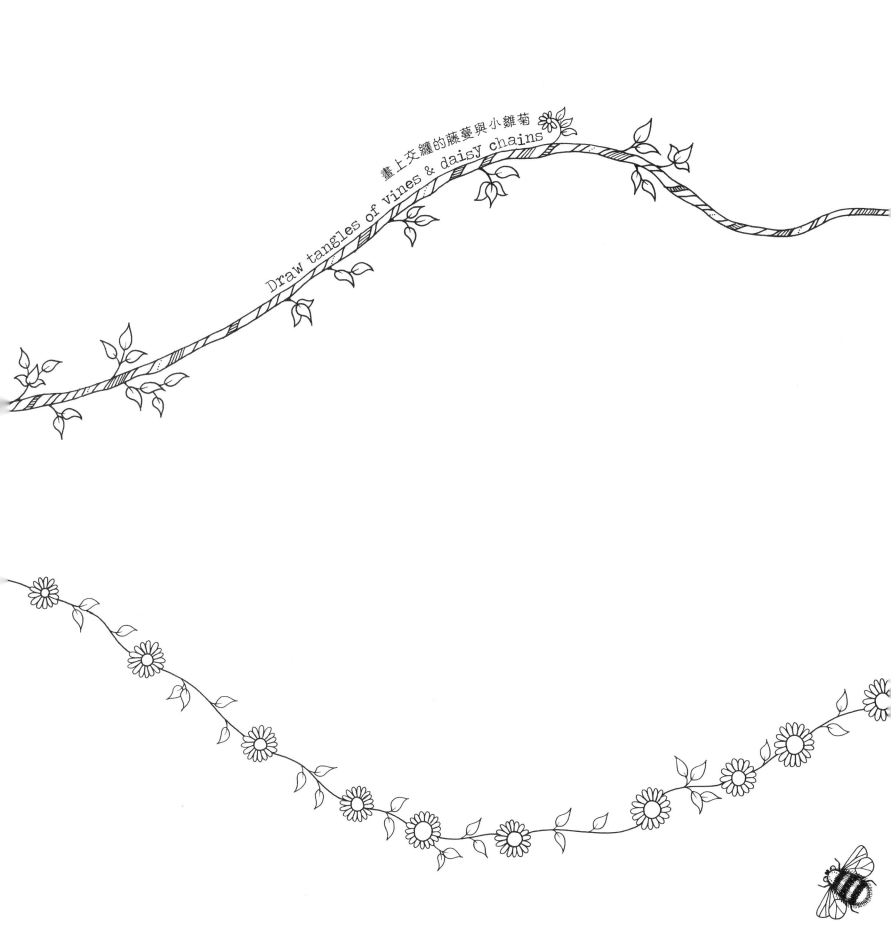

畫上交纏的藤蔓與小雛菊

Draw tangles of vines & daisy chains

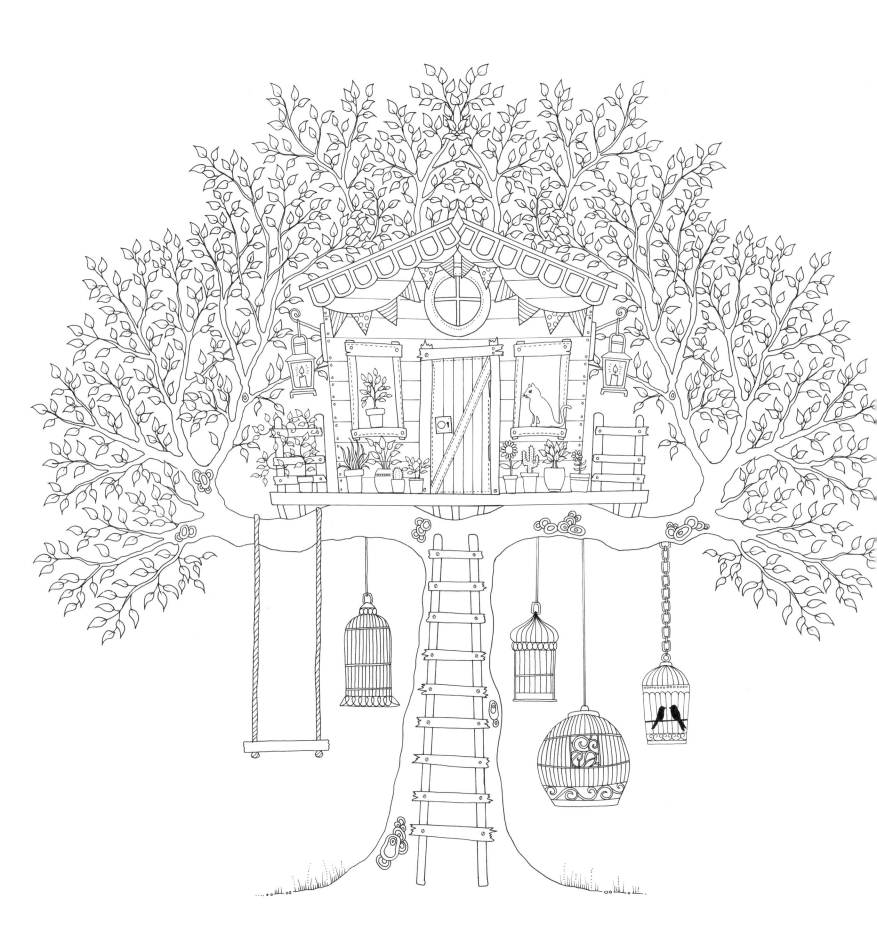

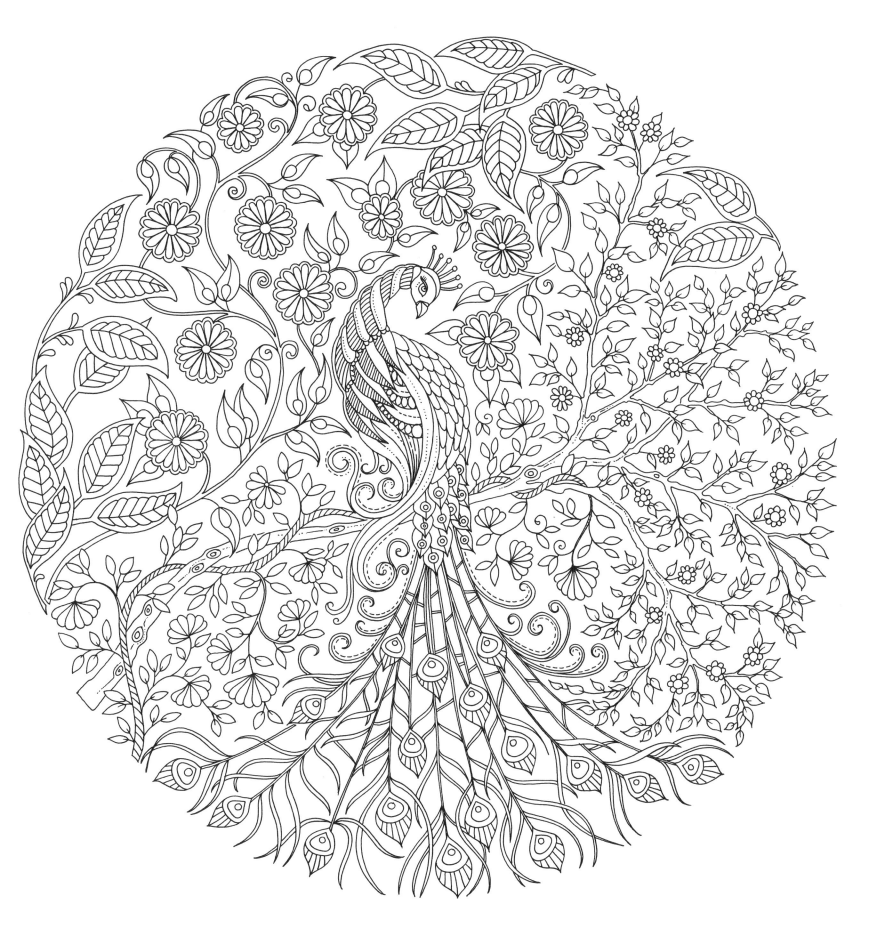

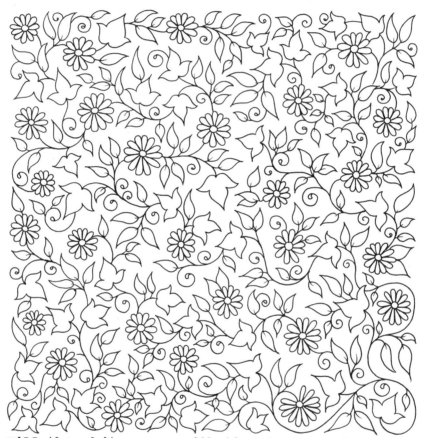

Fill the white space with tiny leaves & blossoms
在空白處畫滿小葉子跟小花

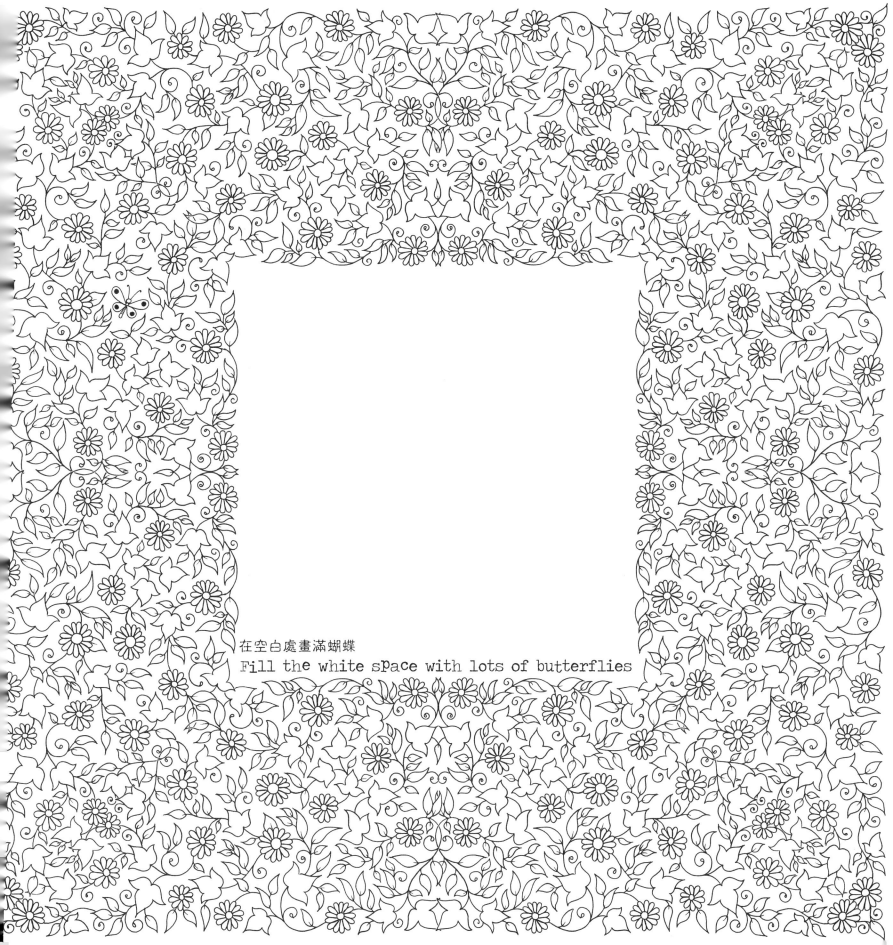

在空白處畫滿蝴蝶
Fill the white space with lots of butterflies

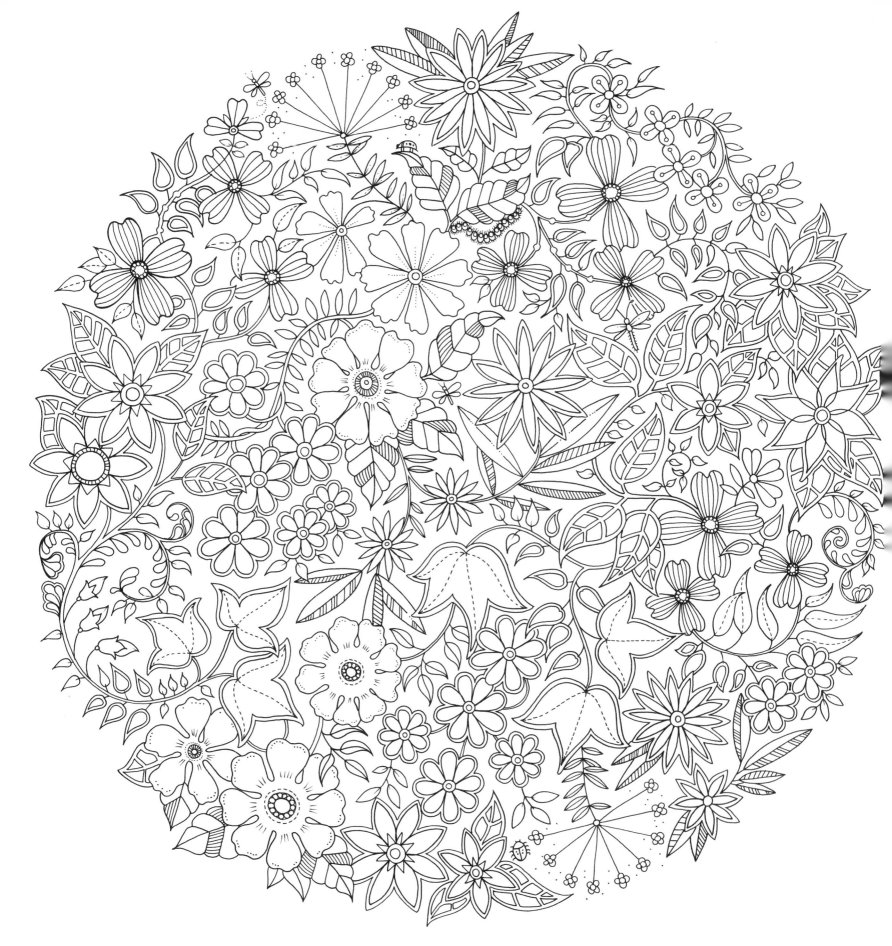

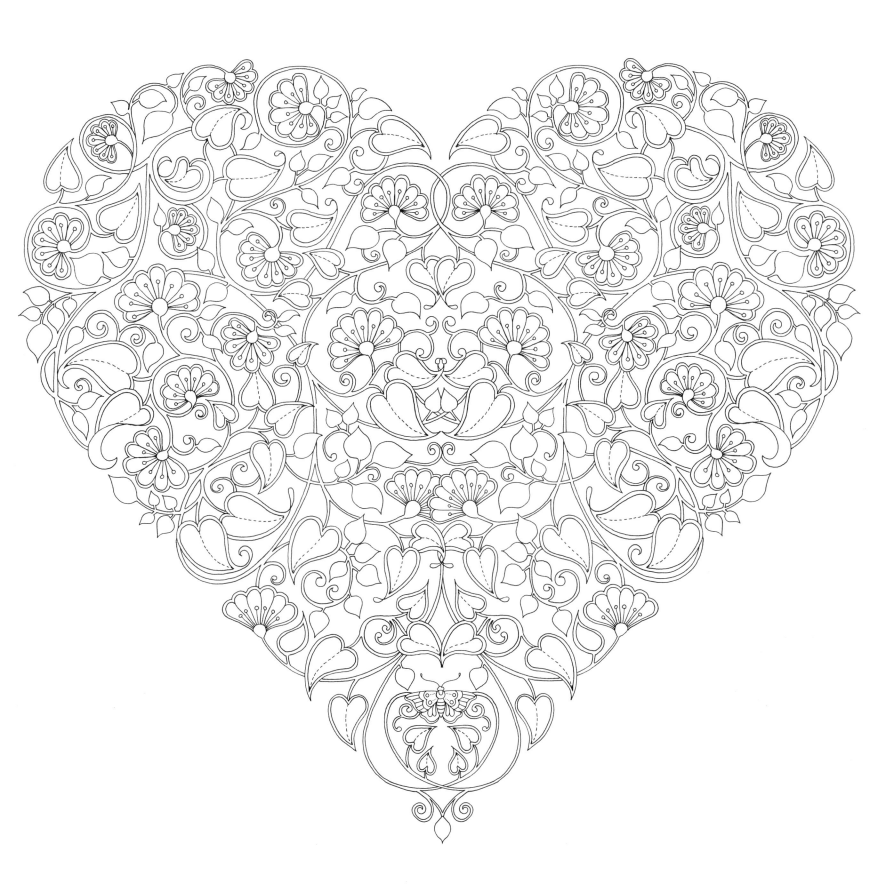

Key to the Secret Garden 秘密花園藏有……

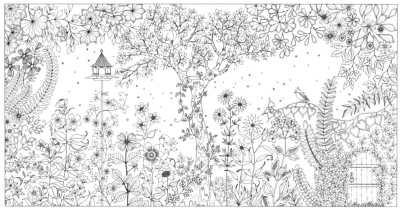

2 song birds, 1 squirrel, 1 key　2隻鳥、1隻松鼠、1把鑰匙

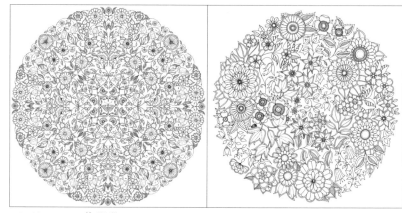

1 butterfly 1隻蝴蝶　　　　　　1 ladybird　1隻瓢蟲

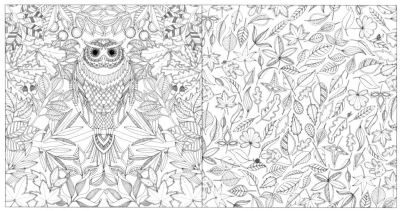

1 owl 1隻貓頭鷹　　　　4 snails　4條蝸牛

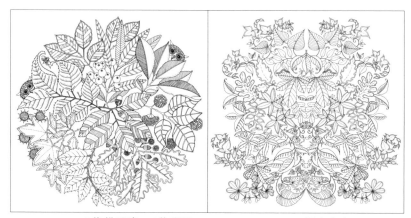

2 owls, 1 bee　2隻貓頭鷹、1隻蜜蜂　6 caterpillars　6條毛毛蟲

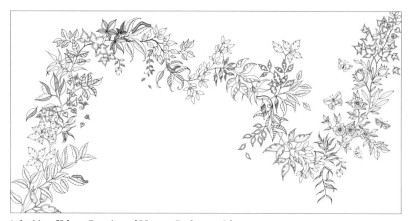

4 butterflies, 3 caterpillars, 3 chrysalises
4隻蝴蝶、3條毛毛蟲、3個蛹

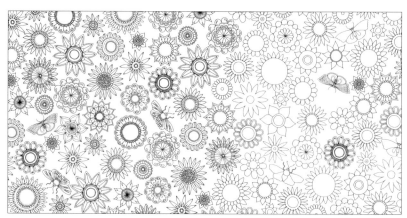

7 butterflies　7隻蝴蝶

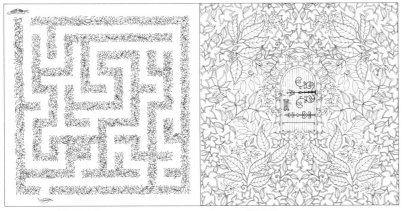

1 slug 1條鼻涕蟲

1 key 1把鑰匙

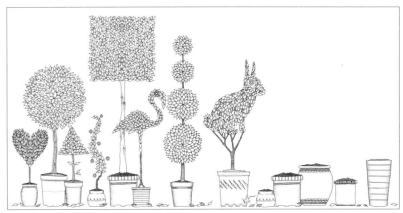

1 mouse 1隻老鼠

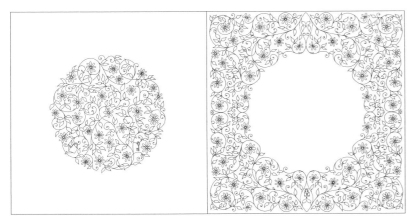

1 key, 1 padlock 1把鑰匙、1個鎖

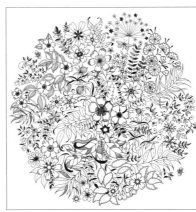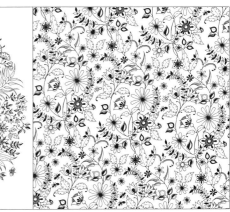

2 bees, 1 butterfly,
1 caterpillar
2隻蜜蜂、1隻蝴蝶、1條毛毛蟲

11 ants, 6 ladybirds
11隻螞蟻、6隻瓢蟲

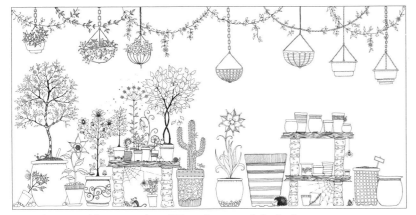

4 snails, 2 spiders, 1 caterpillar, 1 mouse, 1 hedgehog
4條蝸牛、2隻蜘蛛、1條毛毛蟲、1隻老鼠、1隻刺蝟

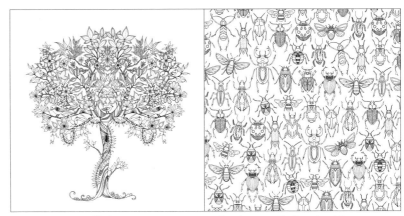

5 song birds 5隻鳥

63 beetles, 5 flying beetles,
4 wasps, 2 moths
63隻甲蟲、5隻在飛的甲蟲、
4隻黃蜂、2隻蛾

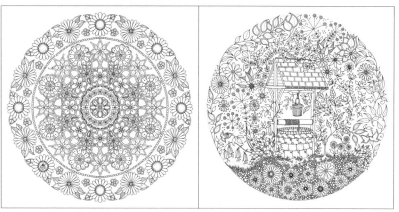

1 ladybird 1隻瓢蟲　　　1 ladybird 1隻瓢蟲

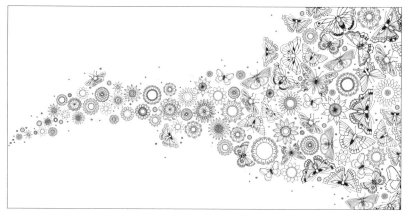

40 butterflies 40隻蝴蝶

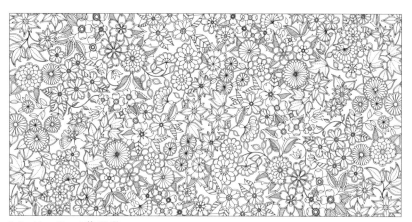

1 butterfly 1隻蝴蝶

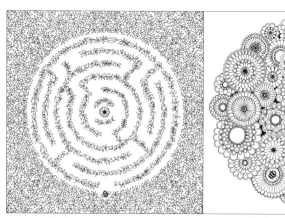

1 bee 1隻蜜蜂　　　1 bee 1隻蜜蜂

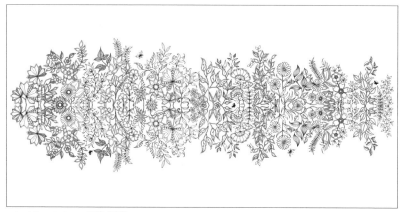

5 butterflies 5隻蝴蝶

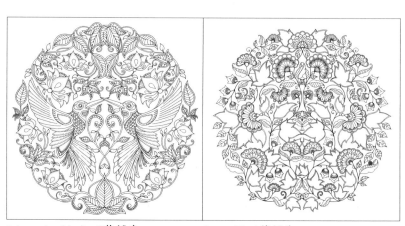

2 hummingbirds 2隻蜂鳥　　　1 snail 1條蝸牛

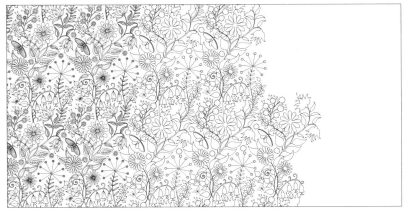

14 butterflies　14隻蝴蝶

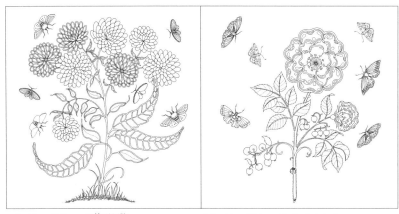

6 butterflies　6隻蝴蝶

6 butterflies, 1 ladybird
6隻蝴蝶、1隻瓢蟲

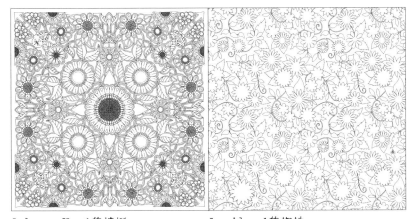

1 dragonfly　1隻蜻蜓

1 spider　1隻蜘蛛

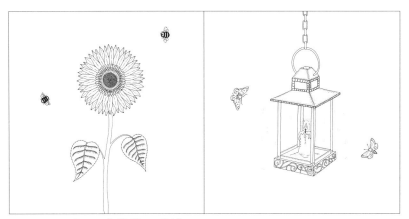

2 bees, 2 moths　2隻蜜蜂、2隻蛾

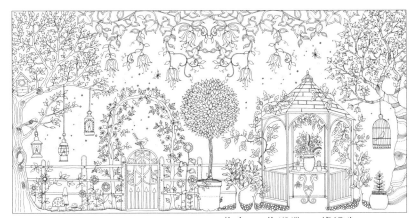

3 song birds, 2 butterflies, 1 snail　3隻鳥、2隻蝴蝶、1條蝸牛

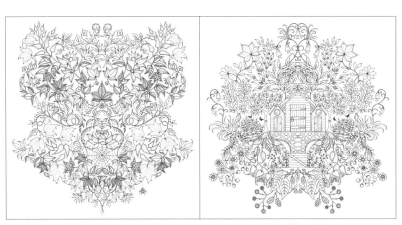

2 spiders　2隻蜘蛛

4 butterflies　4隻蝴蝶

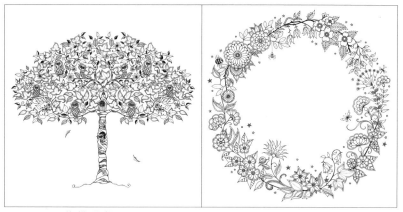

10 owls 10隻貓頭鷹

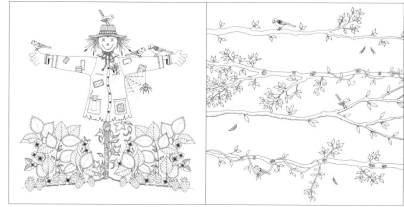

1 butterfly, 1 dragonfly, 1 bee,
1 spider, 1 caterpillar, 1 snail
1隻蝴蝶、1隻蜻蜓、1隻蜜蜂、
1隻蜘蛛、1條毛毛蟲、1條蝸牛

4 song birds, 1 spider, 1 mouse
4隻鳥、1隻蜘蛛、1隻老鼠

3 song birds 3隻鳥

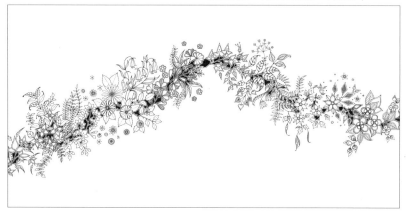

1 ladybird 1隻瓢蟲

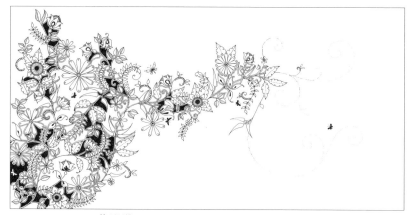

6 butterflies 6隻蝴蝶

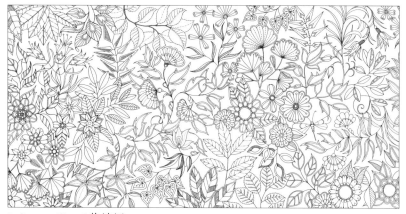

1 dragonfly 1隻蜻蜓

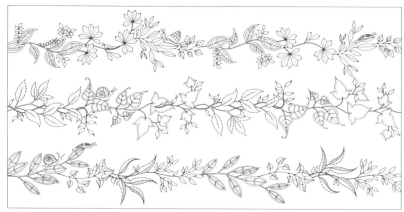

6 slugs, 3 snails 6條鼻涕蟲、3條蝸牛

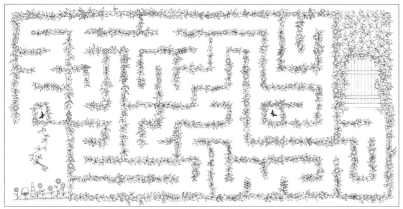

2 butterflies, 1 key 2隻蝴蝶、1把鑰匙

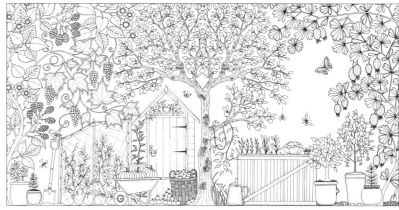

4 butterflies, 1 caterpillar, 1 dragonfly, 1 spider, 1 song bird
4隻蝴蝶、1條毛毛蟲、1隻蜻蜓、1隻蜘蛛、1隻鳥

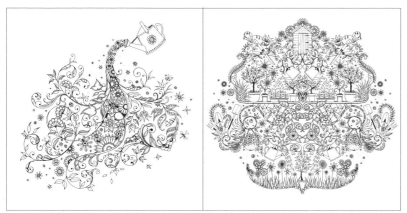

2 dragonflies, 1 butterfly,
1 ladybird
2隻蜻蜓、1隻蝴蝶、1隻瓢蟲

1 ladybird 1隻瓢蟲

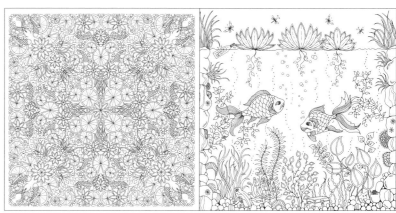

24 fish 24條魚

2 fish, 2 butterflies,
2 dragonflies, 2 snails, 1 frog,
1 shark, 1 treasure chest,
1 message in a bottle
2條魚、2隻蝴蝶、2隻蜻蜓、
2條蝸牛、1隻青蛙、1條鯊魚、
1個藏寶箱、1個瓶中信

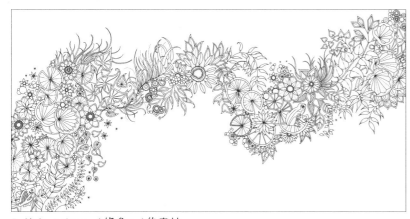

1 fish, 1 frog 1條魚、1隻青蛙

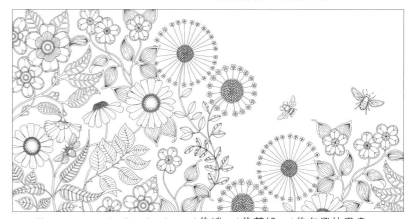

1 moth, 1 wasp, 1 flying beetle 1隻蛾、1隻黃蜂、1隻在飛的甲蟲

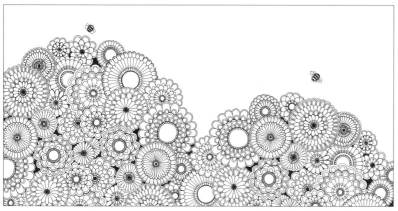

2 bees　2隻蜜蜂

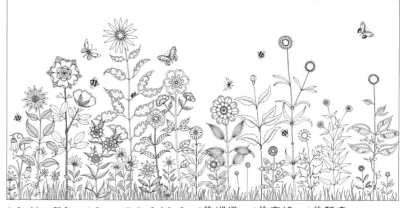

4 butterflies, 4 bees, 1 ladybird　4隻蝴蝶、4隻蜜蜂、1隻瓢蟲

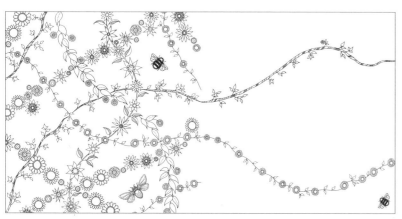

2 bees　2隻蜜蜂

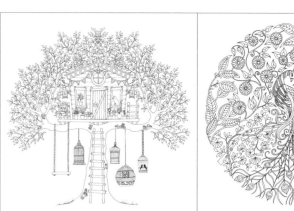

2 song birds, 1 cat
2隻鳥、1隻貓

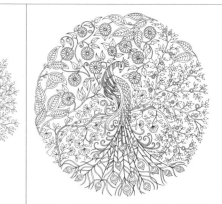

1 peacock　1隻孔雀

2 butterflies　2隻蝴蝶

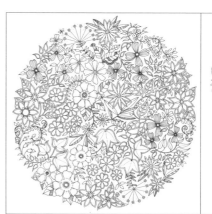

2 butterflies, 2 ladybirds,
1 dragonfly, 1 caterpillar
2隻蝴蝶、2隻瓢蟲、1隻蜻蜓、
1條毛毛蟲

1 butterfly　1隻蝴蝶

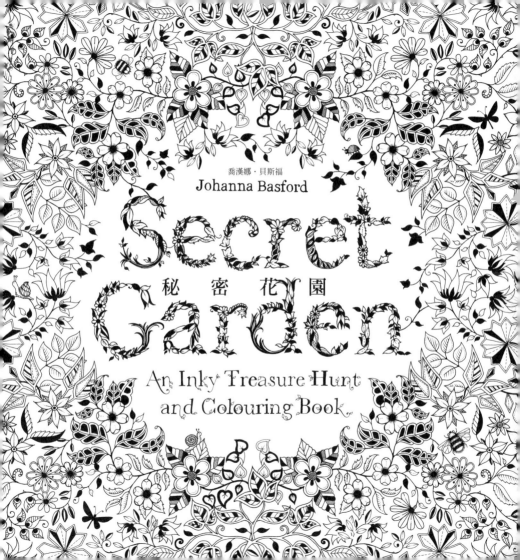

喬漢娜 · 貝斯福

Johanna Basford

Secret

秘 密 花 園

Garden

An Inky Treasure Hunt
and Colouring Book

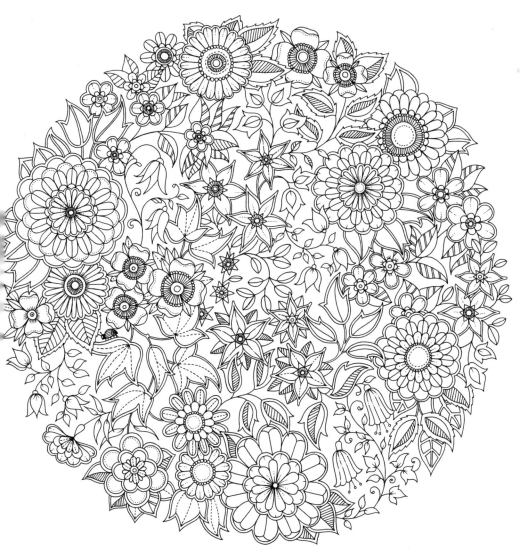

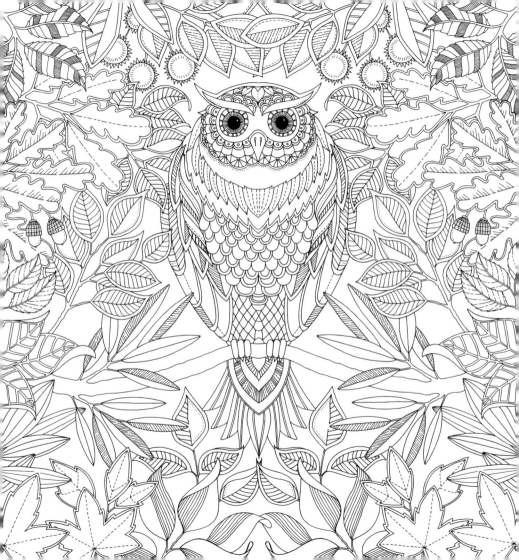

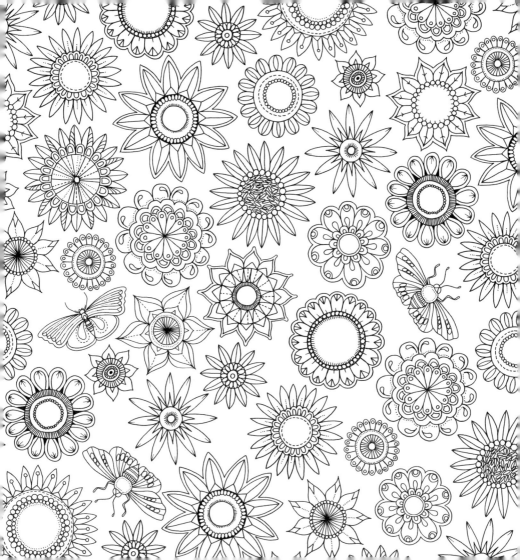

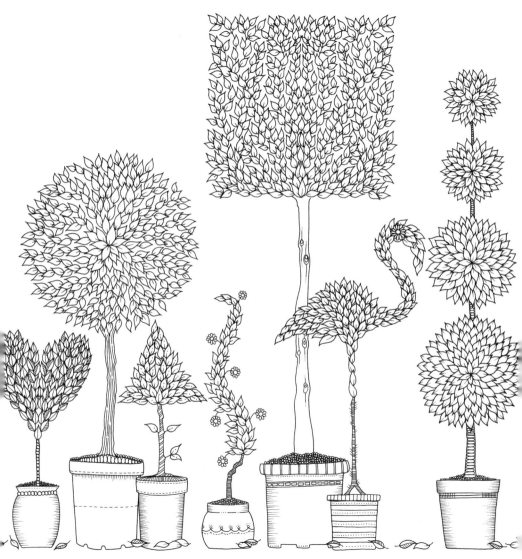

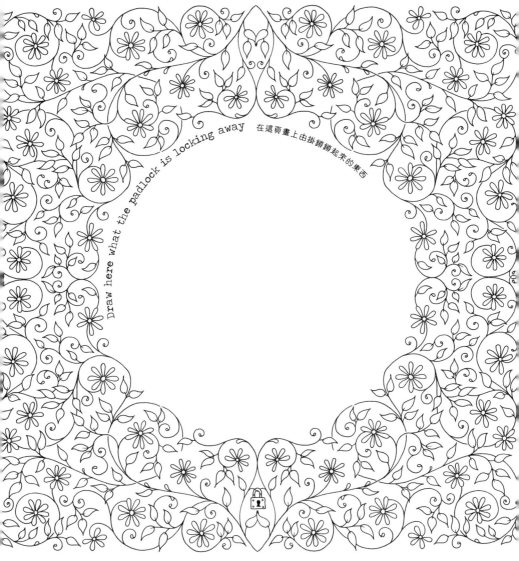

Draw here what the padlock is locking away 在這頁畫上由掛鎖鎖起來的東西

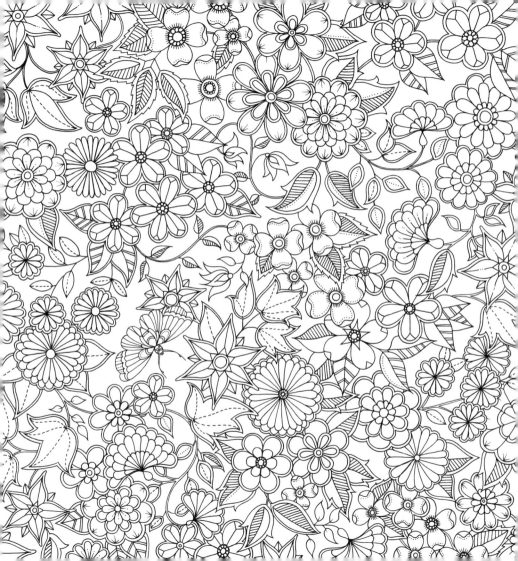

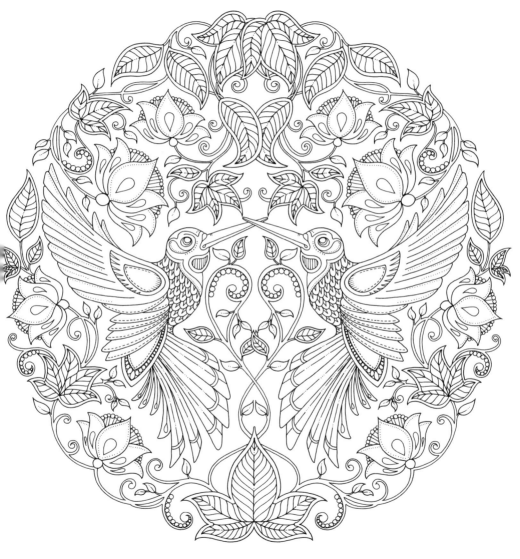

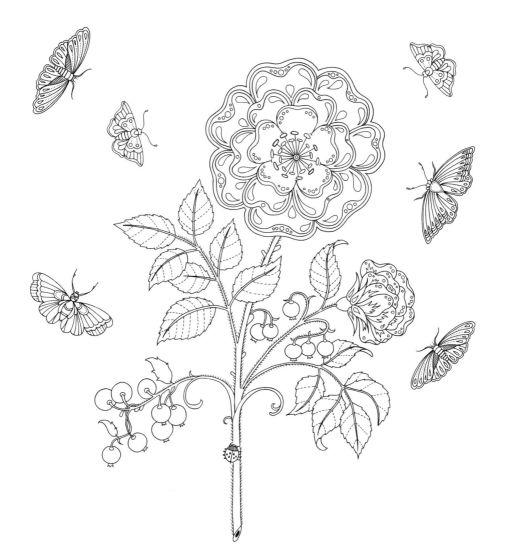

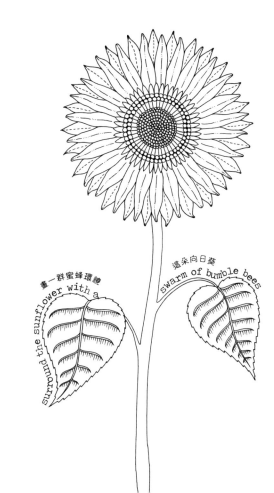

畫一群蜜蜂環繞 這朵向日葵

surround the sunflower with a swarm of bumble bees

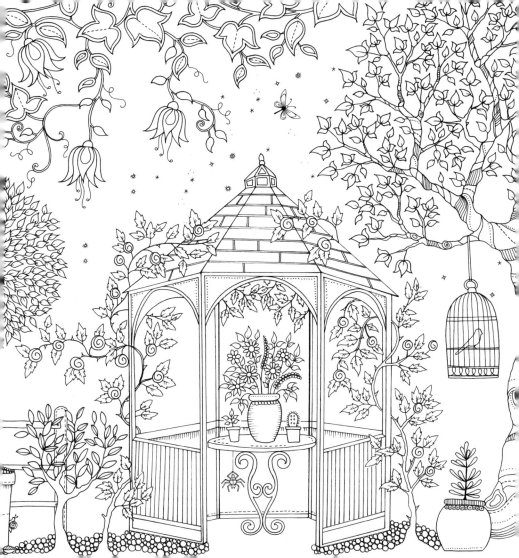

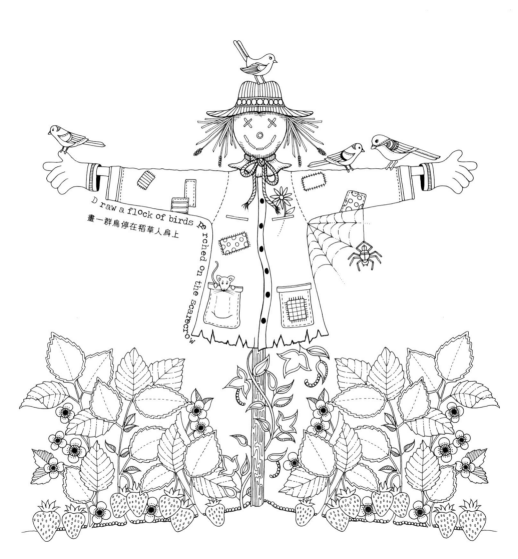

Draw a flock of birds perched on the scarecrow

畫一群鳥停在稻草人身上

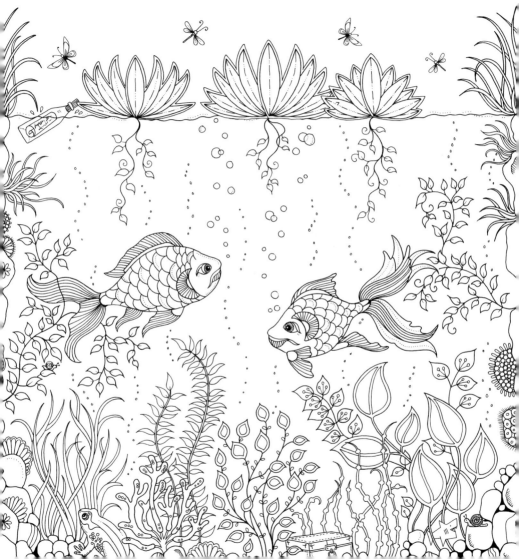

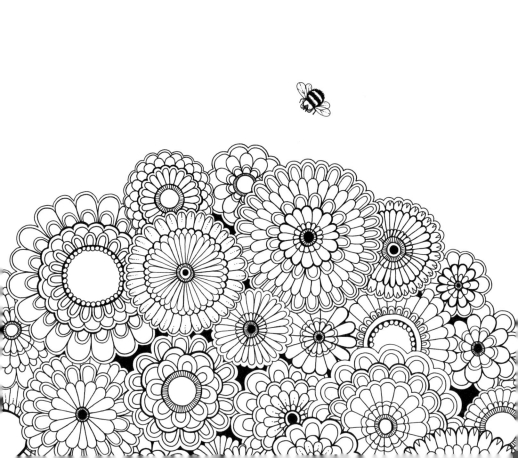

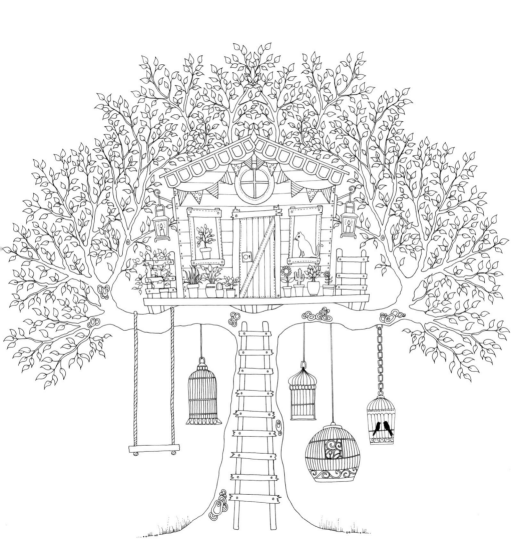

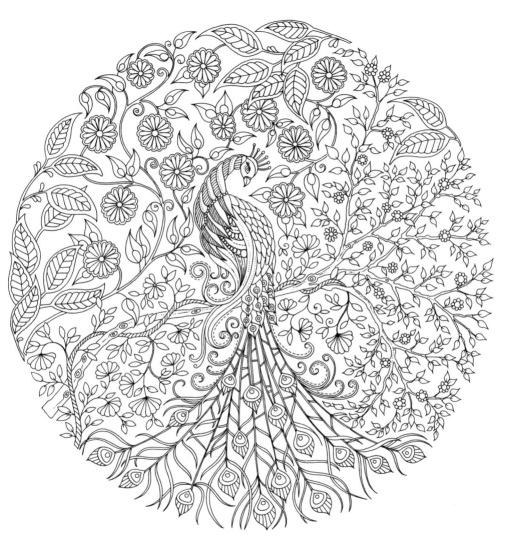

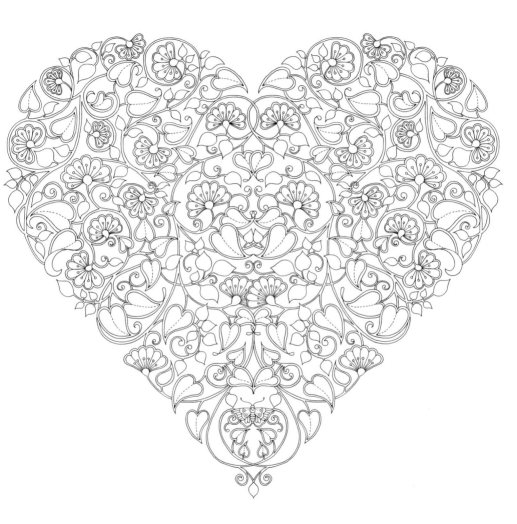

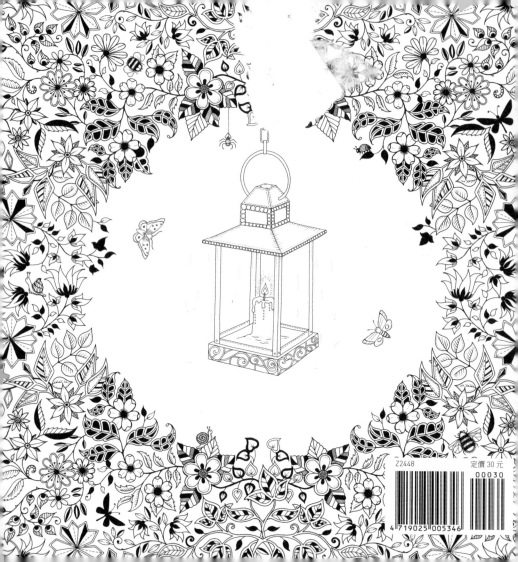

Z2448　定價 30 元

00030

4 719025 005346